WOMEN OF THE 1920S

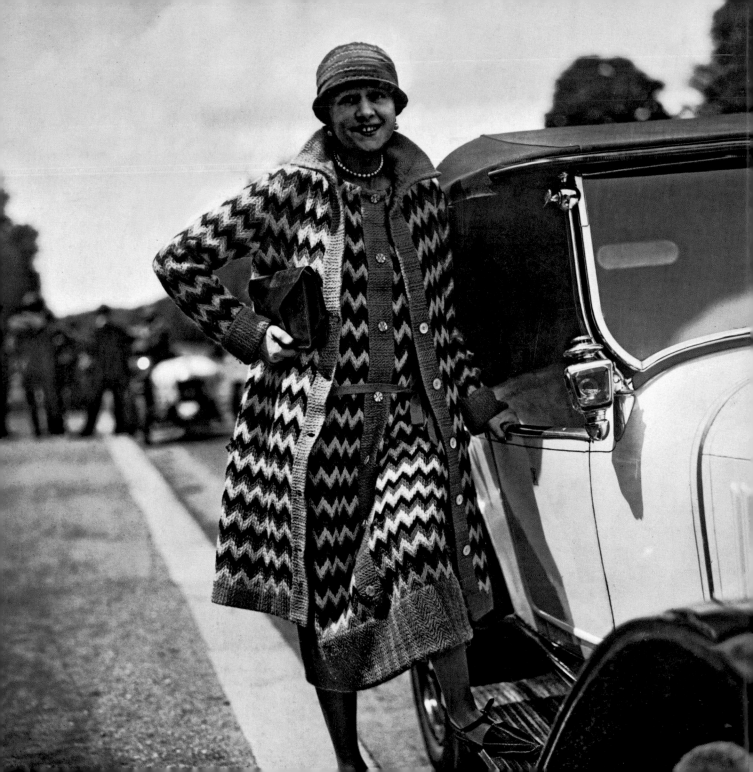

THOMAS BLEITNER

WOMEN OF THE 1920S

STYLE, GLAMOUR & THE AVANT-GARDE

TRANSLATED FROM THE GERMAN BY STEVEN LINDBERG

ABBEVILLE PRESS PUBLISHERS · NEW YORK · LONDON

Front cover: Women strolling on the Champs-Élysées, November 1929.
Back cover: Louise Brooks, ca. 1929.
Page 2: Woman beside a car, ca. 1928.

Picture Credits

Front cover: Imagno/Getty Images; back cover: John Kobal/Getty Images; p. 2: Getty Images; p. 6: Imagno/Getty Images; p. 19: Imagno/Getty Images; p. 20: Mondadori/Getty Images; p. 23: Getty Images; p. 28: Picture Alliance/Everett Collection/© Man Ray Trust, Paris/VG Bild-Kunst, Bonn, 2019, p. 33: ullstein bild/TopFoto; p. 34: UIG/Getty Images; p. 38: Robert Benchley Collection/Howard Gotlieb Archival Research Center at Boston University; p. 42: Imagno/Getty Images; p. 44: © Tamara Art Heritage/VG Bild-Kunst, Bonn 2019; p. 50: Getty Images; p. 53: akg-images/Florilegius; p. 54: Heritage Images/Getty Images/© Man Ray Trust, Paris/VG Bild-Kunst, Bonn, 2019; p. 56: Ryersson & Yaccarino/The Casati Archives; p. 59: Bridgeman Images, Berlin; p. 60: Popperfoto/Getty Images; p. 63: Sept. 1, 1935, *Vogue*, Horst P. Horst; p. 66: George Hoyningen-Huene, © Lee Miller Archives, East Sussex, England, 2019; p. 69: Conde Nast Archives/Corbis; p. 76: John Kobal/Getty Images; p. 79: akg-images/Album/ MGM; p. 80: Jersey Heritage Trust, UK/Bridgeman Images; p. 83: Jersey Heritage Trust, UK/Bridgeman Images; p. 85: Jersey Heritage Trust, UK/Bridgeman Images; p. 86: Ullstein Bild/photo 12/Photos-vintages; p. 89: SZ photo; p. 90: Interfoto/Mary Evans/Illustrated London News Ltd.; p. 92: John Kobal/Getty Images; p. 95: Mondadori/Getty Images; p. 99: ullstein bild; p. 102: The Ziegfeld Club of New York; p. 105: Getty Images; p. 106: ÖNB/Wien, 204338D; p. 108: Archive Elisabeth Sandmann; p. 111: Wikimedia Commons; p. 114: ullstein bild/Roger Viollet/Gaston Paris; p. 117: ullstein bild/Roger Viollet/Gaston Paris; p. 118: Süddeutsche Zeitung Photo/Rue des Archives; p. 122: Nachlass Lothar Schreyer, Hamburg; p. 127: Museum für Kunst und Gewerbe Hamburg; p. 129: Museum für Kunst und Gewerbe Hamburg. p. 130: ullstein bild; p. 132: Interfoto/MaryEvans/Jazz Age Club; p. 134: ullstein bild/Roger Viollet/Boris Lipnitzki; p. 140: ullstein bild/André Kertész; p. 143: Getty Images; p. 144: Scherl/Süddeutsche Zeitung Photo; p. 149: Scherl/Süddeutsche Zeitung Photo; p. 150: ullstein bild/The Granger Collection; p. 152: The Stapleton Collection/Bridgeman Images; p. 155: Getty Images; p. 156: ullstein bild/taglichtmedia; p. 158: ullstein bild/Alex Springer Syndication; p. 161: ullstein bild/taglichtmedia.

For the Abbeville Press edition

Copy editor: S. Collier Brown
Production editors: Amanda Killian and
 Matt Garczynski
Design: Misha Beletsky
Production manager: Louise Kurtz

First published in the English language in 2019 by Abbeville Press, New York

First published in the German language in 2014 by Elisabeth Sandmann Verlag GmbH, Munich, under the title *Frauen der 1920er Jahre: Glamour, Stil und Avantgarde*

Copyright © 2014 Elisabeth Sandmann Verlag GmbH. English translation copyright © 2019 Abbeville Press. All rights reserved under international copyright conventions. No part of this book may be reproduced or utilized in any form or by any means, electronic or mechanical, including photocopying, recording, or by any information retrieval system, without permission in writing from the publisher. Inquiries should be addressed to Abbeville Press, 655 Third Avenue, New York, NY 10017. The text of this book was set in Bernhard Modern. Printed in China.

First edition

10 9 8 7 6 5 4 3 2 1

ISBN 978-0-7892-1347-1

Library of Congress Cataloging-in-Publication Data available upon request

For bulk and premium sales and for text adoption procedures, write to Customer Service Manager, Abbeville Press, 655 Third Avenue, New York, NY 10017, or call 1-800-ARTBOOK.

Visit Abbeville Press online at www.abbeville.com.

CONTENTS

STYLE, GLAMOUR, AND THE AVANT-GARDE

The spell of the 1920s remains unbroken. This brief era fascinates us above all because of the breathtaking pace at which society was changing, the speed with which conventions were being thrown overboard—never before was life so fast, change so radical, or the partying so wild. The First World War swept away the Belle Epoque overnight and gave rise to a generation that rebelled against anachronistic values and vehemently pursued the loosening of social norms. The representatives of that Lost Generation—as they called themselves in reference to a remark by Gertrude Stein—saw their fate as an opportunity; following the motto "Anything goes," they fashioned their lives independently and according to their own ideas. In America and England, the Roaring Twenties began; in France, the Années Folles; and, finally, in Germany—where unemployment and inflation were highest of all, and the

The actress Sibylle Binder, ca. 1925.

economic boom was slow in coming—the Golden Twenties. Many young people at the time were developing a new self-confidence, a new feeling for life; the war had left them with a tabula rasa, and they could, in principle, only succeed: "Dammit, it *was* the Twenties," Dorothy Parker said, "and we had to be smarty."

When it came to shaking off old social customs, women especially distinguished themselves. The changed political and economic conditions after 1918 offered them space for emancipation and unexpected new freedoms. The opportunities for education had improved, and in Germany and other European countries, as well as in the U.S., women's suffrage became a reality along with other basic democratic ideas. Moreover, women were in greater demand than ever in the workforce: Millions of men had died on the battlefields since 1914, and in cities like Berlin the ratio of women to men was at times as high as four to one. Of necessity, working women entered formerly male domains in a variety of fields—also adapting their leisure activities to the changed circumstances—and in the process they discovered the great advantages of their newly acquired autonomy. They thronged the cafés, bars, clubs, and cabarets and lent a new character to the cultural and night life of the metropolises. The Jazz Age that began in America in the early 1920s—popularizing not only the music to which it owes its name but also the Charleston dance in particular—surged from New York toward Europe and inundated Paris, London, and Berlin. Its look was marked by young, rebellious women in calf-length dresses, holding cocktail glasses—Diana Vreeland expressly called the Jazz Age the "martini era"—and cigarettes between their fingers, and chatting casually about self-realization, sex, and their own ideas of morality and decency. In the *New Yorker*, the voice of the young generation in America, Ellin Mackay, a twenty-two-year-old "girl" from Manhattan's high society, wrote: "Modern girls are conscious of their identity and they marry whom they choose, satisfied to satisfy themselves. . . . They have found out that their own individual charm is of more impor-

tance than the badge of social respectability that must be won through the torment of boredom." Like many others, Ellin Mackay did not just leave it at words but acted accordingly: Ignoring the enormous pressure applied by her parents, and despite months spent running the gauntlet of a public hungry for sensation, the daughter of the multimillionaire Catholic financier Clarence Mackay married the Jewish composer Irving Berlin. Her father, who had said beforehand that Ellin would marry the musician only "over my dead body," disinherited her—a fate that would be shared by many a rebellious woman from the upper class.

We had individuality. We did as we pleased. We stayed up late. We dressed the way we wanted. . . . Today, they're sensible and end up with better health. But we had more fun.

—Clara Bow

Ellin Mackay was the epitome of the "flapper." That expression, which referred to the flapping of a young bird's wings, became synonymous with an entire generation of young women who, from the early 1920s, went in search of fun and a new vitality. F. Scott Fitzgerald, who, with his wife, Zelda, was one of the luminaries of the Jazz Age, wrote that the "flapper" is "the girl you see at smart night clubs, gowned to the apex of sophistication, toying iced glasses with a remote, faintly bitter expression—dancing

deliciously—laughing a great deal with wide, hurt eyes. Young things with a talent for living." They wore bobs, cloche hats, and straight-cut Charleston dresses. They detested the affectations of the debutantes, and harbored anything but motherly ambitions, as demonstrated especially by the androgynous, European variant of the flapper type: the *garçonne*, who, with her captivating black-lined eyes and deep-red lips, wearing a monocle and a knee-length skirt or man's suit, frequented the theaters, bars, and cafés of Paris and Berlin. The flapper and the *garçonne* became the image of the modern woman, with all her rights, and the symbol of her sexual liberation. Every one of the women profiled here—however different they were in terms of origins, profession, calling, and age (Luisa Casati and Lee Miller were separated by more than a quarter century)—was in her own way prototypical of the "modern woman" produced by the Roaring Twenties.

This social upheaval took place in the cities. More than in the preceding era, the culture of the 1920s was a culture of the metropolises. For young people who wanted to lead a free life beyond conventional social norms, the city had a powerful draw. The very term "Roaring Twenties" evokes images of a lifestyle that was to be found more or less only in large cities, and these "lifestyle metropolises" were primarily New York, Paris, Berlin, and, to a lesser extent, London, where the tempo of social change was not as rapid and the British regard for tradition was comparatively entrenched. With their theaters, publishing houses, magazines, fashion houses, cafés, and bars, New York and the three European capitals were also the centers of the American, French, German, and British artistic and cultural activity of that time. Their liberal climate attracted avant-garde women in particular and offered them space to develop in freedom—as well as to interact and socialize with one another. In New York, where more alcohol was drunk during Prohibition than ever before, Zelda Fitzgerald, Dorothy Parker, Louise Brooks, and others glamorized the flapper lifestyle, meeting at penthouse parties on Park Avenue or in the countless speakeasies around Broadway where spirits were served

illegally. The bohemians in London met in the West End: in the legendary Café de Paris between Piccadilly Circus and Leicester Square or in the Eiffel Tower restaurant, decorated by the painter Wyndham Lewis, a popular meeting place for artists and Nancy Cunard's favorite haunt before she moved to Paris. Berlin's cultural scene celebrated boisterously in the cafés and theaters on Kurfürstendamm. The city on the Spree, with its countless glamorous variety theaters, was *the* center of dance, and it drew in nightlife habitués with its distinctive subculture. In the 1920s, Berlin was considered the "metropolis of sin"; every evening the city transformed into a rapturous party. "Everything was available; money had no value. You had to spend it because the next day it would be worth even less," Germaine Krull observed, after moving from Munich to the German capital as a young photographer during the era of inflation. And Louise Brooks registered surprise that "collective lust roared unashamed" in the bars and cabarets of the city. Especially in the numerous clubs of the lesbian scene, where Anita Berber, Claire Waldoff, Marlene Dietrich, and others gave legendary performances, the dancing regularly continued into the early hours of the morning.

Without a doubt, however, the metropolis on the Seine had the greatest attraction. Ernest Hemingway was not the only one who recognized that Paris was "a movable feast": the artists, musicians, and bohemians of the young generation swarmed to the city and participated in its creativity. Coco Chanel recalled that in the early 1920s, Paris "was experiencing its strangest and most brilliant years. London and New York (I'm not talking about Berlin, which was buckling then under the throes of devaluation, hunger and expressionism) had their eyes trained on us." Paris was the very cradle of modern culture and—especially where art, photography, and fashion were concerned—the embryo of innovative ideas and trends that would then travel around the world. The extensive colony of American expatriates brought jazz to the bars of Montparnasse and Montmartre, where it was euphorically received and disseminated. In the

studios of artists and photographers, new styles emerged, and haute couture design-
ers—namely, the rivals Coco Chanel and Elsa Schiaparelli—made use of them. "Paris
was a woman"—Andrea Weiss's popular quip was apt. Without its fashion designers and
without Tamara de Lempicka, Gertrude Stein, Lee Miller, Claude Cahun, Josephine
Baker, and Kiki de Montparnasse, Paris surely would not have achieved the splendor
that envelops the city still today.

By the 1930s, the Roaring Twenties must have seemed like a lost paradise. In Oc-
tober 1929, the crash of the New York Stock Exchange triggered the Great Depres-
sion. The buying power of the dollar rapidly sank. In Europe, too, stock markets and
currencies collapsed. Countless companies declared bankruptcy, and on both sides of
the ocean, there occurred unprecedented mass unemployment. In the cities, growing
political tensions and fascist ideologies put an abrupt end to the free spirit of the previ-
ous decade. The era of glamorous feasts and wild parties had come to an end; the Roar-
ing Twenties were history. For most women, this meant career setbacks and, in some
cases, the end of freedom and permissiveness. This was especially true in the Germany
of 1933, where women were made to wear a social corset even tighter than the one
Coco Chanel had only recently loosened. "The 30s were the price that had to be paid
for the 20s," wrote the critic Christopher Bigsby. Many of the courageous women who
had shaped the cultural life and the avant-garde of the Roaring Twenties would feel
this. Some achieved new glories, but for others the end of that decade was also the end
of their success. And several, such as the "volcano dancers" Lavinia Schulz and Anita
Berber, practiced their art and self-realization so radically that they were not even able
to experience the 1930s.

The picture of the daring modern woman who not only smokes and dances but
also drives a car or even flies an airplane is by and large an idealized one—an image
shaped by the magazines of the time. Naturally, the image did not fit every woman of

the 1920s. The countless photographs and illustrations of athletic women behind the wheel obscured the fact that few women had the opportunity to get a driver's license, to say nothing of a pilot's license. Pioneers such as Clärenore Stinnes and Amelia Earhart were exceptions. They were innovators and idols. They communicated self-confidence and exemplified autonomy. This is precisely what links them to all the female protagonists presented in this book. "Woman is tired of being the ideal of the man," Robert Musil wrote in 1929—a sentence that could be the epigraph for each of the seventeen portraits assembled here. The women writers, artists, fashion designers, photographers, actors, dancers, and athletes discussed in the following pages liberated themselves from what Katherine Anne Porter called the "stuffy rules" that society had imposed on them. They broke with traditions and prudery, created styles, spread new values, and lived as they wished. The avant-garde prepared them for one thing above all: fun. Mae West said it best—in a line she might have coined after a strenuous day on stage and a night of dancing the Charleston, pouring sweat, her legs hurting—"You ought to get out of those wet clothes and into a dry martini."

LITERATURE & ART

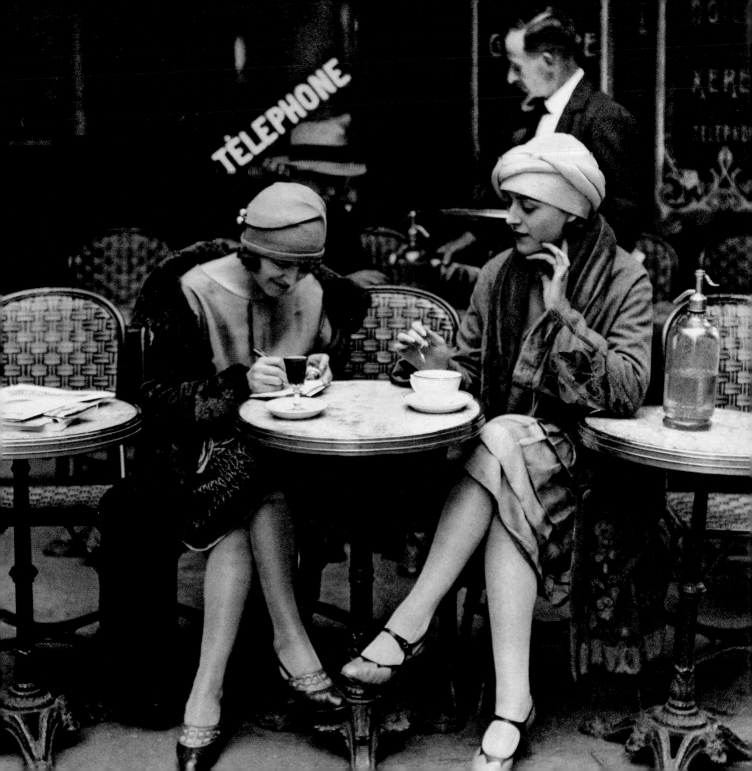

Apassing remark made by Gertrude Stein in conversation with Ernest Hemingway would write history: "You are all a lost generation." Disillusioned by the war and its consequences, searching for their own identity, revolting against an intolerant, petit bourgeois society, this "lost generation" of artists recognized themselves in Stein's pronouncement. She had tapped the pulse of an era.

The dawn of the Jazz Age was also a new dawn for young women seeking freedom from the restrictions on their sex. In New York, Zelda Fitzgerald was not only writing about, but living, the uninhibited life of the flapper. Dorothy Parker too was writing in an atmosphere of bohemian excess: "We were gallant, hard-riding and careless of life. . . . We were little black ewes that had gone astray; we were a sort of Ladies' Auxiliary of the Legion of the Damned. . . . When Gertrude Stein spoke of a 'Lost Generation,' we took it to ourselves and considered it the prettiest compliment we had."

Not coincidentally, the history of the Parisian literary salons is also the history of expatriate American writers. The city on the Seine, the most liberal of all metropolises, offered them ideal conditions for professional and social self-realization. The apartment of the Pittsburgh-born Gertrude Stein was as popular a meeting place for the avant-garde as the salon of Natalie Clifford Barney, who came to Paris from Cincinnati, and as frequented as the Shakespeare & Company bookstore of Sylvia Beach. Djuna Barnes, Solita Solano, Zelda Fitzgerald, and Janet Flanner, who regularly reported for the *New Yorker*, were regular guests in the Paris homes of Stein and Barney. Not all of these women were American expatriates. Helen Hessel and Claire Goll moved to Paris from Berlin and Zurich, respectively. Winifred Ellerman, known as Bryher, and Nancy Cunard both came from London. Bryher's Contad Editions published works by Hemingway and Stein, and Nancy Cunard's Hours Press published texts by the Surrealists and made a work of art of every edition.

A Paris café, ca. 1925.

Tamara de Lempicka also created important works of art. Among the women artists of the 1920s, the Polish painter is the one who best captured the "new woman" in her canvases— and she embodied that type in her own person as well. The permissive provocations of the painter fascinated and unnerved her contemporaries, overshadowing even the achievements of the German-born, Paris-raised Jeanne Mammen who popularized images of Berlin's flappers. Tamara de Lempicka, who came to the French capital from Saint Petersburg, was also from a "Lost Generation": the generation of political émigrés who had to start new existences after fleeing the Russian Revolution.

That was the 'twenties, and anything was possible.

—Kay Boyle

Art and literature came together on the Seine. It is no coincidence that the most popular literary meeting place in London was called the Eiffel Tower and the most beloved artists' bar in Berlin, the Romanisches ("Latin") Café. The charm of the French metropolis was legendary: when the American writer Kay Boyle met Nancy Cunard in the summer of 1923, they soon found themselves dancing on a square not far from Notre Dame to the music of an accordion, a violin, and a piano. "Nobody marveled at the sight of a piano set out in the public street," Boyle later wrote, "because that was the 'twenties, and anything was possible."

Tamara de Lempicka, ca. 1931.

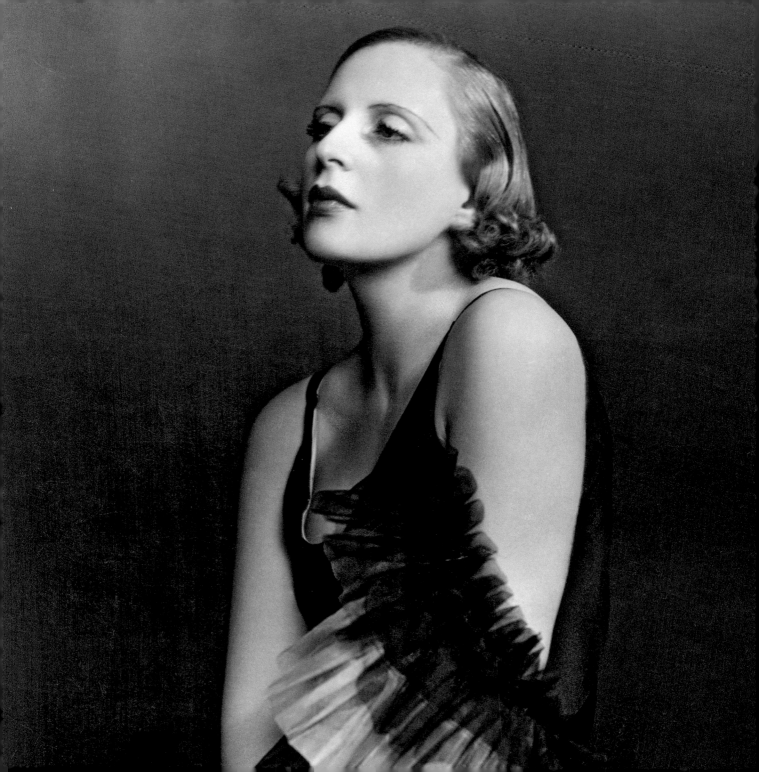

ZELDA FITZGERALD
1900–1948

They didn't make the twenties, they were the twenties.
—Lillian Gish on Zelda and F. Scott Fitzgerald

A brief text, published in *Metropolitan Magazine* in New York in 1922 under the headline "Eulogy on the Flapper," formulated the manifesto of an entire generation. The "flapper," the modern young woman, had prevailed. She "bobbed her hair, put on her choicest pair of earrings and a great deal of audacity and *rouge* and went into battle. She flirted because it was great fun to flirt and wore a one-piece bathing suit because she had a good figure, she covered her face with powder and paint because she didn't need it . . . and she refused to be bored chiefly because she wasn't boring. She was conscious that the things she did were the things she had always wanted to do." It was the slogan of a new, liberated manner and a farewell to puritanism, written by a woman who was the very prototype of what she was describing: Zelda Fitzgerald, née Sayre, the wife of F. Scott Fitzgerald, the most popular American writer of the time.

· — 21 — ·

Zelda Fitzgerald, 1928. She was a passionate ballerina who could have had a great career if the circumstances of her life had not prevented it.

"I was in love with a whirlwind and I must spin a net big enough to catch it out of my head," Scott Fitzgerald wrote in retrospect. The two met in 1918 in Zelda Sayre's hometown, Montgomery, the capital of Alabama, where the writer was stationed as a lieutenant in the infantry. The young Zelda was considered a gifted dancer—a talent that was encouraged from the outset by her parents. Her father was a justice on the Supreme Court of Alabama and her artistically inclined mother was from the upper classes of the South. She quickly learned to put herself at the center of social events and in the public eye. "She might dance like Pavlowa," the *Montgomery Advertiser* judged, "if her nimble feet were not so busy keeping up with the pace a string of young but ardent admirers set for her." She was the most coveted girl in the city and caused Scott Fitzgerald to squirm for a long time before she yielded to his courting and moved with him to New York.

With his very first novel, *This Side of Paradise*, published just before the two married in 1920, Scott Fitzgerald achieved his breakthrough. The newspapers fought over his short stories, and the high royalties he was now pocketing were spent on ever-changing hotels and apartments, opulent dinners, expensive shopping excursions, visits to the theater, dissolute nights in the revues on Broadway or in "speakeasies"—the illegal, hidden bars that were booming during Prohibition—and on parties, which they either threw themselves or were driven to, sitting on the roofs of New York taxis. Rivers of champagne and gin flowed, and Zelda Fitzgerald in particularly was always ready for escapades; not infrequently, she jumped fully clothed into public fountains or unclothed into the bathtubs of her baffled hosts. "She is without doubt the most brilliant & most beautiful young woman I've ever known," noted Alexander McKaig, who was himself a passionate partygoer and a good friend of Scott Fitzgerald from their time together at Princeton. Her progressive husband put up with his wife flirting now and again. She even flattered him by saying that she was merely living out the ideals of the female

Zelda and her husband F. Scott Fitzgerald, 1921. While peaceful-looking, he tended toward violent outbursts, especially after consuming large quantities of alcohol.

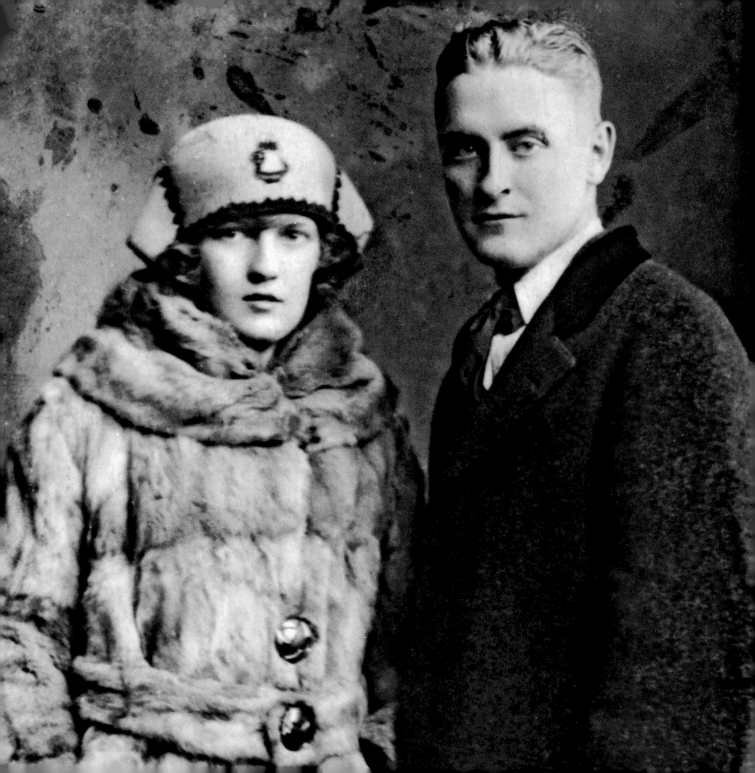

characters of his stories. Zelda and Scott Fitzgerald were the dream couple of the Jazz Age—an era that owes its name to Scott Fitzgerald's short-story collection *Tales of the Jazz Age*. They shone, Dorothy Parker stated, "as though they had just stepped out of the sun."

Scott Fitzgerald did, however, act jealously when his wife began to develop her own ambitions to write. Their excessive partying, which the two did not even abandon after their daughter, Scottie, was born in 1921, did not satisfy Zelda Fitzgerald in the long run. She had frequently accused her husband of using her diaries, sometimes word-for-word, in his own texts, without making any reference at all to their author. When George Nathan, the editor of the magazine *The Smart Set*, showed interest in her diaries and offered to publish excerpts from them, Scott Fitzgerald managed to prevent it, very much to his wife's chagrin. By the time his novel *The Beautiful and Damned*—unmistakably a roman à clef about their own relationship—was published, their marital bliss had cooled considerably, especially as the alcohol consumption of the star author had taken on pathological qualities, and in the meanwhile the couple was spending much more money than Scott's publications were bringing in.

In 1924, the debt-ridden Fitzgeralds ventured a new start. They took a ship to France and rented the Villa Marie for the summer, located in the hills above Saint-Raphael on the Côte d'Azur, where they met Pablo Picasso and Fernand Léger, both prominent members of the Parisian avant-garde. Their new life started off well, as France was considerably cheaper than New York. Scott Fitzgerald was drinking moderately and working at full speed on a new novel. But his wife's affair with a French air force officer triggered a crisis that would remain unresolved despite a move to Italy, where life was even more inexpensive. On Capri, Zelda Fitzgerald met the American artist Romaine Brooks, who awakened in her an interest in painting. This rather ascetic period soon came to an end, however. In April 1925, the novel on which Scott

Fitzgerald had been working so intensely was finally published. *The Great Gatsby* was a success, at least financially, enabling them to resume in Paris the exclusive life they had abandoned in New York.

In the cafés and clubs of Montmartre and in the Dingo American Bar on rue Delambre, their regular bar in Montparnasse, the couple celebrated lavishly, though little by little they were going their separate ways. Scott Fitzgerald befriended Ernest Hemingway, whom he had met at the Dingo. With Hemingway, Scott drank more than ever. Zelda quickly developed a strong aversion to Hemingway and criticized his macho pose. No one is as masculine as he pretends to be, she scoffed. Hemingway, in turn, complained that her obstinacy was harming her husband's genius and career. Zelda Fitzgerald, meanwhile, preferred to meet the independent, successful professional women of Paris's Left Bank, above all Natalie Barney and Gertrude Stein, whose salons she attended. Spending time with them probably encouraged her decision to take up again the dancing career she had cut short in her youth. It could be that dancing provided a form of therapy as well for her increasing psychological instability.

Just be myself and enjoy living.

—Zelda Fitzgerald

The intense dance instruction that Zelda Fitzgerald had from Lyubov Yegorova, the head of the ballet school of the Ballets Russes, ultimately culminated in successful performances in Nice and Cannes. But because the lessons were expensive, and their finances were, once again, worsening as the alcohol consumption of her husband increased, she offered Harold Ober, Scott Fitzgerald's renowned agent, short stories she

had written herself and thus began competing directly with her increasingly unproductive husband. As much as he disliked her incursion into his domain, he soon managed to profit from it: several of her short stories appeared under his name, because they brought in more money that way. Regarding one of Zelda's stories, Scott Fitzgerald told Ober that *College Humor* magazine could credit it to both Scott and Zelda if they were willing to pay $1,000; but if the magazine could come up with only $500, they had to credit it to Zelda alone. For her story "A Millionaire's Girl," he demanded four thousand dollars and to be credited as its sole author. The *Saturday Evening Post*, in which the story was published, ultimately identified it as his. Zelda Fitzgerald's depression worsened. The couple had returned to America for good in 1931. During an extended

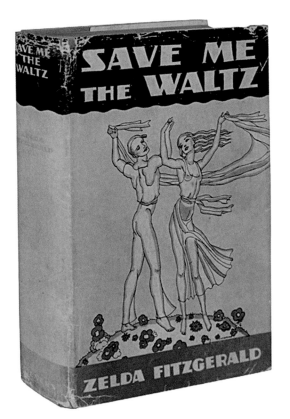

stay in a clinic in Baltimore, and encouraged by the physician Mildred Squires, she wrote her autobiographical novel *Save Me the Waltz*. This time Scott Fitzgerald would not be named as the author, nor would he be involved in the content: "I would like you to thoroughly understand," she informed him, "that the other material . . . is nevertheless legitimate stuff which has cost me a pretty emotional penny to amass." The book was published by Scribner's in 1932, and even though it was sometimes perceived as a gossipy exposé of the failures of a celebrity couple, it received a positive response and serious reviews.

As far as Zelda's mental health was con-

The cover of Zelda Fitzgerald's autobiographical novel *Save Me the Waltz*, which can also be read as a portrait of the society of the 1920s.

cerned, her liberating literary coup came too late. Her suicide attempts grew more frequent, and in the years that followed she left clinics more rarely. In 1948, she died in a fire at the Highland Hospital in Asheville, North Carolina. For ten years, Scott Fitzgerald wrote, she had moved "at top speed in the gayest worlds," and as the model woman of the Roaring Twenties, perfectly personified the self-determined woman her husband had promoted in his books. "Indeed, I married the heroine of my stories," Scott Fitzgerald admitted. When his "heroine" began to take her autonomy literally, however, their dream relationship broke up. At the same time, Zelda had achieved something significant: "Mrs. F. Scott Fitzgerald started the flapper movement," the contemporary press proclaimed. She kindled a movement that would become associated with her personally, not with her husband or the characters in his novels.

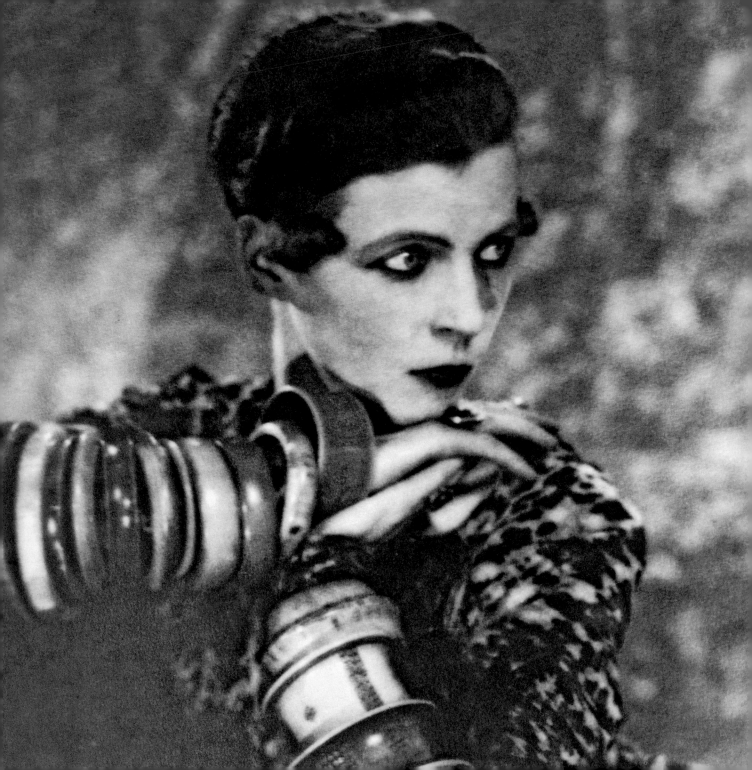

NANCY CUNARD
1896–1965

*Nancy Cunard . . . inspired half the poets
and novelists of the 'twenties. They saw her as
the Gioconda of the Age. . . .*
—Harold Acton

n December 1930, a serious scandal struck the London townhouse of Lady Emerald Cunard, who had made a name for herself as a *salonnière* of the cultural and political high society, and who was accustomed to evaluating the exploits and social faux pas of others. But this time Lady Emerald herself was affected. Her daughter, Nancy Cunard, had been living in Paris since 1923. Like her mother, Nancy was regarded as eccentric and rebellious. Her latest escapade overshadowed all of her past ones. Alcohol and drugs were not the problem this time. It was her love affair with the black jazz pianist Henry Crowder, which was causing quite a stir in London's upper class. Nancy's plan to travel with Crowder to the British capital was seen as an additional provocation. Lady Emerald openly threatened to have them both charged criminally in a kangaroo court and deported. Nancy Cunard responded promptly and publicly. In a polemic

· — 29 — ·

Nancy Cunard was the muse of numerous interesting men of her time, including Man Ray, who took this photograph of her in 1926.

she published in 1931 called "Black Man and White Ladyship: An Anniversary," she wrote, "But your Ladyship, you cannot kill or deport a person from England for being a Negro and mixing with white people. . . . No, with you it is the other old trouble—class."

As irreconcilably opposed as mother and daughter were, their lives reveal certain parallels. Like Nancy Cunard, Lady Emerald too had once turned her back on the narrow-minded society from which she came and had moved from America to England in 1895 with Sir Bache Cunard, the well-heeled scion of the powerful Cunard cruise line. Nancy Cunard tried early on to escape the comparatively conservative salon society that her mother received first in Leicestershire and later in a house on Grosvenor Square in London. She married the Australian officer Sydney Fairbairn in 1916, without her mother's blessing. It lasted two years and was followed by a longer, problematic affair with Aldous Huxley, whom she met at the Eiffel Tower, London's literary and artistic meeting place.

Her literary gift was much greater than her talent for uncomplicated relationships. In 1916, Edith Sitwell included seven poems by Nancy Cunard in the anthology *Wheels*. Nine years later, she had her greatest success with the extensive poem "Parallax," which was compared positively to T.S. Eliot's "The Waste Land." Even the critical *Times Literary Supplement* confirmed that the work was the "creation of a resilient mind." At the time, Nancy Cunard was already living in Paris. The poet Ezra Pound, who knew her already in England and met her again in France, had repeatedly encouraged her to publish her poems, even before "Parallax" appeared, as did the journalists Janet Flanner and Solita Solano.

Flanner and Solano were a colorful couple on Paris's Left Bank and quickly became good friends of Nancy Cunard. Dressed in the most elegant garments by Poiret and Vionnet, which Lady Emerald was always sending her daughter from London (unrequested), the three women became a glamorous constellation, frequenting the cafés and

restaurants of the metropolis on the Seine and numerous parties at Nancy Cunard's apartment on the rue Le Regrattier. Painters and photographers literally begged them to model; in particular, according to Solita Solano, "Nancy's Egyptian head with Nefertiti's proud eyes and fine taut mouth painted scarlet" had impressed a wide variety of artists. Winifred "Bryher" Ellerman, writer and contemporary, recalled her as "most arresting. . . . Every head turned to stare at her when she entered a room." The photographers Man Ray, Curtis Moffat, and Cecil Beaton; the painters Oskar Kokoschka and Wyndham Lewis; the writers Aldous Huxley, Ezra Pound, and Tristan Tzara were just a few who portrayed Nancy Cunard in their work.

> *[Nancy Cunard] was one of the superrich, even though she had been disinherited by her mother. . . . On the one hand, a thoroughly English snob, on the other hand, she plunged headlong into every venture, especially all battles for human rights.*
>
> —Claire Goll

For avant-gardists like André Breton, who revolutionized art with his "Manifeste du surréalisme" in 1924, Nancy Cunard was the ideal woman. In the Bureau of Surrealist Research (Centrale Surréaliste), the public meeting point for artistic innovators, she met Louis Aragon, with whom she formed for two years, in Claire Goll's view, "a droll

and happy couple"—until the relationship ended in a great quarrel on a trip to Venice in the summer of 1928. During their fierce fight, Aragon essentially threatened to kill himself. When Nancy Cunard did not take him seriously, he took an overdose of sleeping pills. He was saved just in time by employees of the hotel. "I don't think anyone has ever loved me save Louis," she later wrote in a letter to Janet Flanner. "I, on the other hand, have truly and entirely loved many." That same year, Nancy Cunard realized a project that had occupied her since the beginning of her writing career. With the help of the considerable inheritance she received after her father's death, she founded the Hours Press—a publishing house for bibliophiles. All the books from the Hours Press were printed by hand in small runs using eighteenth-century type. "Nancy, the last of the famous Cunarders, steers her hand press into the stormy literary seas of the Montparnasse Surrealists," wrote the *Paris Tribune*, and with names like Aragon, Pound, Man Ray, Yves Tanguy, and Samuel Beckett—whose first separate publication, *Whoroscope*, was released by the Hours Press—the press was indeed rich in prominent Surrealists.

The press also published *Henry-Music*, a work on the music of Henry Crowder, whom Nancy Cunard had met in a Venetian jazz bar in 1928 after the disaster with Aragon. The book included her own essays, alongside essays by Beckett and photographs by Man Ray. Her greatest literary achievement, however, was the publication in 1934 of her unprecedented anthology *Negro* by Wishart & Co. in London. Nearly 900 pages long, with 150 articles and 550 illustrations, it was a cultural, political, and historical documentation of the life of African Americans. It was also a courageous, avant-garde manifesto against exclusion and discrimination.

Nancy Cunard never lacked courage. In 1931, she traveled with Crowder to London as announced. Both were able to evade the detectives whom Lady Emerald had hired to pursue them. In the end, they remained in London for an entire month. Nancy Cunard

always advocated for human rights with the same uncompromising commitment she showed in her love affairs. Her passion was enormous. It may even have gone too far at times: Janet Flanner once asked Henry Crowder if he had got his black eye in a traffic accident. No, he replied, it was "just bracelet work."

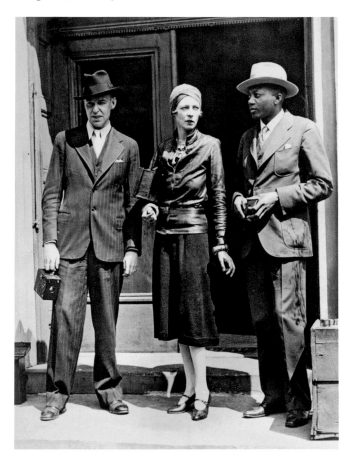

Nancy Cunard in front of the Grampion Hotel in Harlem, with John Banting (left) and Taylor Gordon, in May 1932.

DOROTHY PARKER

1893–1967

Dammit, it was *the twenties and*
we had to be smarty.
—Dorothy Parker

Even a modern and liberal magazine such as *Vogue* did not wish to expose itself to the accusation of circulating indecent texts. Immediately before the issue in question was supposed to go to press, the editor responsible stopped a risqué caption adorning a photograph of a model in an expensive negligee: "There was a little girl," it read, "who had a little curl, right in the middle of her forehead. When she was good she was very very good, and when she was bad she wore this divine nightdress of rose-colored mousseline de soie." This cheeky commentary was ahead of its time. Ten years later, it might have got through, but in 1915, the readership of *Vogue* would not tolerate such intimations. The author was the young copywriter Dorothy Rothschild, who was, according to *Vogue* editor-in-chief Edna Woolman Chase,

Dorothy Parker in an elegant fur
stole and fashionable hat.

"a small, dark-haired pixie, treacle-sweet of tongue but vinegar-witted." Thanks to these unorthodox captions, Rothschild quickly made a name for herself. She was soon writing longer contributions, though the work remained controversial. Even her headlines raised eyebrows. "Interior Desecration," for example, was the title she used to target a certain interior designer who, in her opinion, had butchered a luxury villa. The final editor had overlooked the pun, which subsequently got the magazine into a great deal of trouble.

Aperçus like these became, for Dorothy Parker, a kind of trademark. Parker wrote under her maiden name until 1917, the year she married the Wall Street stockbroker Edward Parker. Raised on the posh Upper West Side of Manhattan as the youngest of four children, she had a rather joyless childhood and felt abandoned after her mother's sudden death in 1898. The rebellious "Dottie" hated her stepmother, and she distrusted her environment and developed a cynicism that was already pronounced in her younger years. Her obstreperous temperament led to her expulsion from Blessed Sacrament Academy, a Catholic private school on 79th Street. Parker later recalled that her dismissal probably had as much to with her irreverence as it did her cynicism—"my insistence," for example, "that the Immaculate Conception was spontaneous combustion." This did not do any harm to her career as a journalist. On the contrary, it proved advantageous. Shortly after her promising debut at *Vogue*, Dorothy Parker moved to *Vanity Fair*, where she was the first woman in her hometown to write theater criticism. After her husband was drafted into the medical corps and stationed in France, she began a remarkable career, ultimately becoming New York's most popular theater and literary critic—as well as an icon of the New York party scene. With the journalist Robert Benchley, an editorial colleague at *Vanity Fair*, she would spend nights wandering through the speakeasies of Manhattan. She became one of the founding members of

the legendary Round Table at the Algonquin Hotel between Broadway and Fifth Avenue. The Round Table hosted a regular set of young bohemians and talented writers, journalists, and actors. Dorothy Parker was the undisputed focus.

Frank Case, the manager of the Algonquin, called them "the hopefuls of the future." Starting in June 1919, they met regularly for lunch in the Rose Room of the hotel. In addition to Dorothy Parker and Benchley, the first members of the Round Table included the influential *New York Times* critic Alexander Woollcott, the actor Harpo Marx, and Harold Ross, who would found the epochal magazine *The New Yorker*. Later, they were joined by the writer Edna Ferber, the actress Tallulah Bankhead, and the illustrator Neysa McMein, all of whom became good friends of Dorothy Parker. Looking smart was the rule at the Algonquin, not just where rhetoric was concerned. Dorothy Parker liked to show up wearing white gloves and broad-brimmed hats. Occasionally she wore, as her biographer Michaela Karl writes, "a feather boa, which often landed in the plates of the other guests and at times caught fire when someone lit a cigarette." Along with Tallulah Bankhead, the very incarnation of the flapper, Parker was famous for her beauty, her legendary consumption of gin and cigarettes, her numerous affairs, and her habit of addressing everyone as "darling." With Edna Ferber, Benchley, and the Round Table's committed core, Dorothy Parker also initiated the Vicious Circle, which usually met in Neysa McMein's studio—a studio with a bathtub, which proved handy in the era of Prohibition.

The Algonquin was only a stone's throw from the theaters on Broadway—Dorothy Parker's work world. Shortly after she was tossed out at *Vanity Fair* for insulting the wife of Florenz Ziegfeld, Jr., founder of the legendary Broadway revue *Ziegfeld Follies* and close friend of *Vanity Fair*'s publisher, Condé Nast, Parker became a freelance critic and journalist. Benchley also left the magazine out of solidarity with his colleague. They

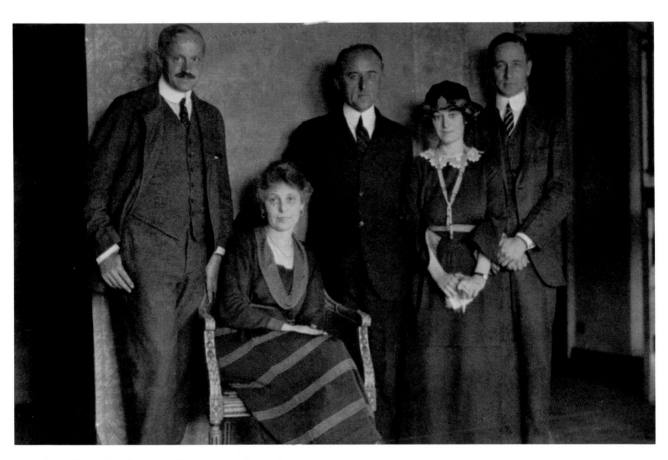

Dorothy Parker and Robert Benchley (right) with Frank
Crownshield (*Vanity Fair*), Edna Chase (*Vogue*), and the pub-
lisher Condé Nast, 1919. *Vogue* became an international
success after Nast acquired the magazine in 1905.

rented a one-room office together near Times Square. It was "so tiny," she later stated, "that an inch smaller and it would have been adultery." She worked for a number of magazines and was responsible for a much-read column in *Ainslee's Magazine*. With the publication of "Such a Pretty Little Picture" in the magazine *The Smart Set* in 1922, she had her breakthrough as a fiction writer. The critics, including William Somerset Maugham, fell head over heels in love.

To the same degree that Dorothy Parker shone professionally, her private happiness was lacking. Increasingly, the Round Table became Dorothy Parker's home. Her marriage had been moving toward its end ever since her husband had become a notorious drinker after returning from Europe. "I require only three things of a man. He must be handsome, ruthless, and stupid," she stated. Disillusioned after separating from Edward Parker, she plunged headlong into the parties of the Vicious Circle and into a series of unpromising relationships. She, too, was drinking excessively now, especially since, after moving into the Algonquin Hotel in 1924, her path to the bar was much shorter. Over time, this proved detrimental to her work. Her articles, short stories, and poems, which she usually published in the *New Yorker*, rarely arrived on time. The publisher George Palmer Putnam once motivated her to submit a text by threatening to call the police. By 1926, Dorothy Parker had fallen into a deep depression. As a therapeutic measure, she moved to Paris for a lengthy stay.

The circle of exiles in Paris around Zelda and Scott Fitzgerald, Ernest Hemingway, and the wealthy couple Sara and Gerald Murphy welcomed Parker with open arms. Her relationship to Hemingway, whom she considered a snob, was ambivalent from the start, but the Murphys, whom she later visited in their villa on the Côte d'Azur, restored the courage Parker needed to face life. After returning home, she became politically engaged as a journalist. She wrote about racism and discrimination against minorities. Her first volume of poems, *Enough Rope*, published in late 1926, became a

great success, along with her column in the *New Yorker*, "The Constant Reader." Many of her legendary literary reviews were published there. Authors at the time feared them. Assessing a novel by Nathalie Colby, for instance, she wrote, "There are a cast of characters as long as that of a Player's Club revival, and Mrs. Colby, with none too gentle a push, thrusts so many people into her opening pages that the reader is in grave danger of being trampled on in the mob." William Lyon Phelps's book *Happiness* was another victim of her unparalleled bons mots: "It is second only to a rubber duck as the ideal bathtub companion. It may be held in the hand without causing muscular fatigue or nerve strain, it may be neatly balanced back of the faucets, and it may be read through before the water has cooled. And if it slips down the drain pipe, all right, it slips down the drain pipe."

Miss Hepburn ran the whole gamut of emotions—from A to B.

—Dorothy Parker on the actress Katharine Hepburn

Toward the end of the decade, no critic's pen was sharper than that of Dorothy Parker. Nor did any other author write short prose the way she did. Her piece "Big Blonde" was named the short story of the year in 1929. The distinction led to financial relief and to a well-paid contract for a novel. She never wrote the novel, but her first collection of short stories, *Laments for the Living*, was a great success. Celebrations inevitably followed, as did Parker's old habits. She crashed. On one occasion, she drank a bottle of shoe polish and ended up in the hospital. Further "escape attempts" to France around 1930 were unsuccessful. Dorothy Parker was a New Yorker through and through, and

as much good as Europe did her, she could not let go of her homeland. Only when she moved to Hollywood with the actor and writer Alan Campbell did peace return. In 1952, she came back to "her" city. New Yorkers felt she had never left. As the writer and Round Table participant Donald Ogden Stewart recalled, "It wasn't difficult to fall in love with her. She was always ready to do anything, to take part in any party; she was ready for fun at any time when it came up, and it came up an awful lot in those days."

TAMARA DE LEMPICKA
1895/98–1980

*I live life in the margins of society, and the rules of
normal society don't apply in the margins.*
—Tamara de Lempicka

When Tamara de Lempicka set her mind on someone—whether as a model, for a liaison, or more—as a rule she got what she desired. This captivating spontaneity, which was in the painter's blood, was often very profitable, as her memory of a visit to the theater in Paris demonstrates: Lempicka saw a pair of bare shoulders she admired on a woman she did not know seated before her in the audience. "When the lights came up, she turned her profile, and I looked at her and I thought . . . 'This is what I need'. . . . And I touched the woman on her shoulder. I said, 'Madame, my name is Tamara de Lempicka. I'm a painter. I'm doing now a big work. Five personalities. One is missing, and that one is you. Would you sit for my painting . . . nude?' She looked at me with level eyes. And she said, 'I will sit for your

· — 43 — ·

Tamara de Lempicka, 1932.
Photograph by Dora Kallmus.

painting.'" Presumably neither the artist's popularity nor the prospect of a fee motivated the stranger to accept the unusual offer. Like so many of Lempicka's contemporaries, the stranger succumbed to her sensuous charm. The painting in question was very probably the group nude *Le rythme*, which was painted around 1924.

Lempicka was enjoying some success at the time, but her fame beyond the Parisian circles of her fellow bohemians had yet to reach its peak. The paintings would continue to inflame the public's fascination, as would the licentiousness for which "la belle Polonaise" was known. Lempicka had affairs with women as well as men, indiscriminately inspired by their beauty. At her parties and receptions, lavish tables of food, drink, and narcotics were provided by nude servers. All of this, combined with a mysterious past, made Lempicka one of the shining lights of the Années Folles.

Still today, both the place and year of her birth puzzle biographers. It is reasonable to assume that this daughter of a wealthy Polish family of the *grande bourgeoisie* was born in 1895, not in 1898 as official documents have it, and probably not in Warsaw, as is frequently stated, but in Moscow. Née Tamara Górska, Lempicka spent her youth among the high society of Saint Petersburg, where she married the lawyer and playboy Tadeusz

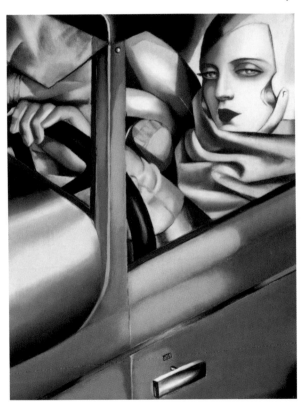

Tamara de Lempicka's self-portrait:
Autoportrait (Tamara in a Green Bugatti), 1929, oil on wood panel, 13¾ × 10⅝ in. (35 × 27 cm), private collection.

Lempicki and fled with him to Copenhagen after the October Revolution broke out. Tamara de Lempicka had thus already seen several metropolises before they and her daughter, Kizette, settled in Paris in 1918. They moved into a modest hotel room, initially living off the money from a diamond ring they sold. Because of Tadeusz Lempicki's inability to find work and the financial pressures that resulted, Tamara de Lempicka began studying art at the Académie Ranson, where Moise Kisling was one of the teachers. In her youth, she had been sent to him for drawing lessons. Following controversies at the Académie Ranson, she broke off her studies and took private lessons with the Cubist painter André Lhote, who recognized her talent and encouraged it. By 1920, Tamara de Lempicka was selling her first paintings.

After the family had moved into a three-room apartment on the rue Guy de Maupassant, Tamara de Lempicka enjoyed her part in the lively artistic and cultural scene of Montparnasse. That neighborhood, and the other haunts of bohemian Paris, provided her with inspiration. In the bookstores of Sylvia Beach and Adrienne Monnier, she felt as much at home as in the Café du Dôme, Deux Magots, and Café La Rotonde, where paintings by Kisling, Chaim Soutine, and Amedeo Modigliani were hanging— canvases that the artists had used to pay their tabs in times of financial difficulty. With the tip of her cigarette elegantly balanced between her fingers, her nails painted with bright red polish, and her expressive gestures, Lempicka captivated her contemporaries. In addition to Natalie Barney, Janet Flanner, and Marika de la Salle, whom she painted, Tamara de Lempicka also met Ira Perrot, a neighbor from the rue Guy de Maupassant who modelled for her for more than ten years and became her best friend—probably also her lover.

Starting in 1922, the Salon des indépendants and the Salon d'automne, central forums for avant-garde artists, regularly exhibited Lempicka's paintings. *Figaro* lauded them. Until 1925, Tamara de Lempicka worked manically. She derived inspiration

not only from the public at the salons, bars, and cafés but from the shows of the Revue Nègre with eighteen-year-old Josephine Baker. Afterward she would often sit down before the easel, heady and full of enthusiasm, and paint until the early morning hours. "Tamara was playing the game hard by anyone's standards," writes her biographer Laura Claridge. "She was determined to embody that icon of the age, the new woman."

For me, Tamara de Lempicka is the first Pop artist in the history of art.

—Wolfgang Joop

These nightly excesses were indispensable to Lempicka's work. In numerous nudes, she assimilated her milieu, creating fascinating variations of a "modern woman" who no longer denied her own sexual needs. Lempicka's painting *Two Girlfriends* caused a sensation at the Salon d'automne. In 1927, another painting, called *Beautiful Rafaela*, turned heads. Fifty years later, the *Sunday Times Magazine* would call it "one of the most magnificent nudes of the century." As a pioneering representative of the Parisian avant-garde, Tamara de Lempicka always preserved an individual style. She lent her figures Cubist forms, clear colors, and a distinctive charisma. They were cool and sensuous. She derived little inspiration from the artistic innovators of Surrealism. The *Exposition internationale des arts décoratifs et industriels modernes* in Paris, from which the name Art Deco derives, and her first large solo exhibition in Milan helped her achieve an international breakthrough in late 1925. "Not only . . . Paris [has] acclaimed the art of Madame de Lempitzka," reported *Vanity Fair*, after which society's upper crust stood

in line to have their portraits painted. Several of Tamara's paintings—including her famous self-portrait in a green Bugatti—graced the cover of the popular Berlin fashion magazine *Die Dame*.

In 1929, an affair with the Italian poet Gabriele D'Annunzio ended her marriage. She moved into a generously furnished studio apartment, designed in part by Le Corbusier, on the rue Méchain. Thanks to her relationship with, and later marriage to, Baron Raoul Kuffner, a wealthy Hungarian collector of her paintings, Lempicka survived the years of the Great Depression relatively unscathed, though the art market ground to a halt. In 1933, her works were in greater demand than ever. Loving "art and high society in equal measure," as her friend Jean Cocteau described it, was key to Lempicka's enduring success. That love was sometimes fraught. The more conservative among the social elite, for instance, found some of Lempicka's party antics disturbing. When she invited her guests to partake of the cheese and grapes covering the nude waiters and waitresses, one can only imagine the shock. But in the end, no harm was done to her success. "Genius, in art," said Cocteau in 1922, "consists in knowing how far we may go too far." More than any other artist, Tamara de Lempicka pursued this credo of the avant-garde.

SOCIETY & FASHION

t was true both of Parisian high society and of the city's artistic bohemia: there was always a party to go to. That both spheres would meet at one and the same party was something new to the 1920s. "Beaumont became the inventor of a new form of snobbism requiring that value take precedence over title, talent over wealth, artists over the establishment": according to the Coco Chanel biographer and fashion journalist Edmonde Charles-Roux, that is how the Parisian patron of the arts Comte Étienne de Beaumont selected the guests for his legendary masked balls. Beaumont's parties were large, popular events and by no means restricted to high society—the bohemians, too, were welcomed with open arms, whether they had a name or not. The blue-blooded Luisa Casati, "Queen of the Night" in a diamond dress by Léon Bakst, celebrated casually alongside Kiki de Montparnasse in clothing she designed herself from comparatively simple materials. Equally diverse—just not as colorful—were the cocktail parties of Condé Nast on Park Avenue in Manhattan, where Josephine Baker danced the Charleston, Dorothy Parker bantered, and both toasted the failure of Prohibition. Lee Miller broadened her contacts with star photographers Edward Steichen and Cecil Beaton. "Everybody who was invited to a Condé Nast party stood for something," the columnist and fashion designer Diana Vreeland wrote: "He was the man who created the kind of social world that was then called Café Society: a carefully chosen mélange—no such thing as an overcrowded room, mind you—mingling people who up to that time would never have been seen at the same social gathering. Condé picked his guests for their talent, whatever it was—literature, the theater, big business."

For the fashion makers of the time, the lively gatherings that Nast, de Beaumont, and other networkers of the 1920s organized offered ideal chances to determine the effect of their creations in social circles and to pick up the scent of trends. "Fashion is in the air, it is borne on the wind, you can sense it, you can breathe it. . . . It has to do with ideas, with social mores, with events," wrote Coco Chanel, who liked to show off her

A woman in a cloche hat, 1927.
Photograph by Sasha.

latest creations at the Comte de Beaumont's events. In one of her numerous brilliant gambits, she hired him as the manager and designer of her Bijoux de couture, or jewelry workshop. In addition to de Beaumont's balls for aesthetes, the parties at Maison Watteau, organized by the Swede Lena Börjeson and favored by the Cubists and Surrealists, provided much inspiration to the city's couturiers. Sonia Delaunay and Elsa Schiaparelli, the artists among the fashion designers, were welcome guests. Together with her husband, Robert, and Tristan Tzara, Sonia Delaunay designed Cubist and Dadaist clothing as works of art, and Elsa Schiaparelli created her Surrealist collection, which would prove to be her breakthrough.

In addition to drawing on contemporary art, the fashion of the 1920s emphasized comfort. "You must dress a body in fabric, not construct a dress"—that was how Madeleine Vionnet summed up the credo of fashion creators of that time. Coco Chanel's dresses caused women's waists to vanish. She made the slim-fit look, which offered optimal mobility while remaining socially acceptable. The athletic look triumphed, even in evening dress. In the mid-1920s the Charleston dress and the "little black dress" were the moneymakers of the fashion houses. They preserved as much freedom of leg movement as possible and enabled the wearer to dance through the night. Elsa Schiaparelli soon thereafter was designing bathing, tennis, and skiing fashions that emphasized the body and added essential facets to the public appearance of the modern woman. The Parisian star photographer George Hoyningen-Huene presented the creations of both the Italian designer and Coco Chanel. One of his favorite models was Lee Miller; she regularly wore the collections of the rival designers in *Vogue* before she took up the camera herself in 1929 and worked as a photographer.

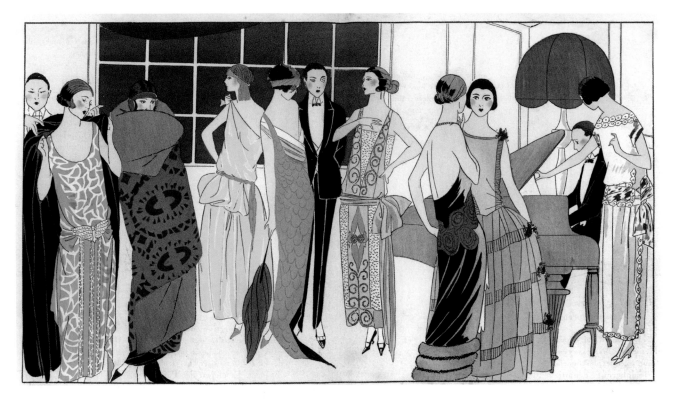

A party scene from *Art, Goût, Beauté*, 1923.

When a woman smiles, her dress
must smile with her.

—Madeleine Vionnet

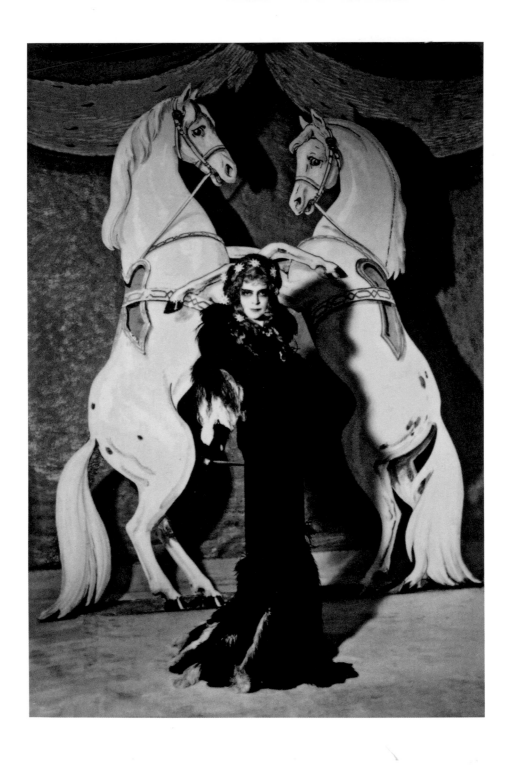

LUISA CASATI

1881–1957

*Tall and gaunt, with heavily made-up eyes, she represented
a past age of splendor when a few beautiful and wealthy women
adopted an almost brutally individualistic way of living
and presenting themselves to the public.*
—Elsa Schiaparelli

The fuss that Luisa Casati caused when she disembarked the transatlantic passenger steamer S.S. *Leviathan* in New York was enormous. The metropolis on the East Coast was the first station of a trip to America she began in late 1925. Reporters from the sensationalist press were already lining her route. A scandal had occurred on the crossing: a boa constrictor—an indispensable part of the Italian designer's evening wear—had escaped on board, which frightened the other passengers. Fortunately, the animal did not reappear, much to the sorrow of its owner.

"La Casati, as she is known, is famous not only for her extraordinary good looks but for her taste for the exotic, the bizarre, the spectacular," the *San Francisco Chronicle* explained to its readers. Applause and admiration for the unconventional star from Europe were omnipresent. The American *Vogue*, for example, described a dinner in

The Marchesa Luisa Casati, costumed as Empress
Elisabeth of Austria. Photograph by Man Ray, 1934.

Florida at which the marchesa appeared wearing a gold-brocade evening dress and a gold helmet with black feathers as the "the smartest night at the Everglades." Luisa Casati had been famous since the turn of the century for her erratic moods and her individual style. Although the fashion of the 1920s—marked by the bob and accessories such as the cloche hat and the "little black dress"—sometimes made the chic marchesa seem a bit behind the times, she fascinated the art scene, especially the avant-garde in Paris. Her confession to American gossip reporters thus sounded as credible as it was coquettish: "To be different is to be alone. I do not like what is average. So I am alone."

As a young heiress of wealthy textile entrepreneurs in Milan, Luisa Amman—her maiden name—was one of the best eligible bachelorettes in all of Italy. In 1900, she married the Marchese Camillo Casati Stampa di Soncino; however, she quickly grew bored of the unspectacular life at his side. The newly minted marchesa developed an interest primarily in high-speed excursions by horse and automobile. She was equally drawn to everything mystical and to the writer Gabriele D'Annunzio, with whom she soon began a passionate affair. D'Annunzio's unconventionality, focus, and courage fascinated her; he awakened her genius. "Because, however, she regrettably lacked talent for a specific direction in art," the author and art historian Claudia Lanfranconi writes, "she stylized herself into a work of art." The trademarks of

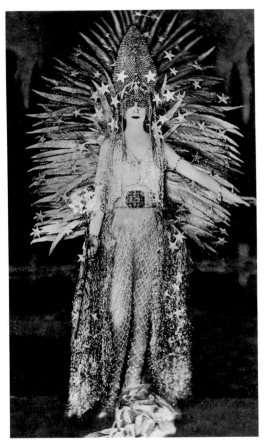

The Marchesa Luisa Casati as the "Queen of the Night" in a costume by Léon Bakst, 1922. She wore this outfit embroidered with diamonds at the masked ball of the patron of the arts Comte Étienne de Beaumont.

this self-promotion included darkly outlined eyes, hair dyed red, clothes set with precious stones, and above all, the exotic animals with which Luisa Casati adorned herself. At the parties and soirees she threw in her palazzi in Rome and on the Canal Grande in Venice, she often received her guests draped in snakes and with predatory cats at her side. When she moved to Capri in 1920, the Caprese were astonished by her cheetah. She walked it on a leash—one of a "succession of glorious shocks," her contemporary Lady Diana Cooper once wrote.

> *She was certainly the most extrava-*
> *gantly odd woman I have ever met.*
>
> —Erté

One person Luisa Casati shocked was the artist for whom she modeled at Capri. During the creation of the painting, the artist, the American Romaine Brooks, was on the edge of a nervous breakdown several times, because the marchesa developed an obsession with both the work of art and its creator. "I am exhausted," Brooks wrote to her life partner in London, Natalie Clifford Barney, "I am losing weight, I am losing my hair, I am afraid, I need my rest." The painting depicts Luisa Casati as mystical, androgynous, batlike creature, contrasting strikingly with a portrait by the Spanish painter Federico Beltrán y Masses from that same year that presents the marchesa as much more down-to-earth and modern. Beltrán y Masses was one of the first artists to translate the fin-de-siècle aura that Luisa Casati radiated into the aesthetic of the 1920s. Kees van Dongen also painted Casati, but Man Ray set himself apart from her other portraitists. Soon after she moved to Paris in 1922, Man Ray took a series of

Surrealist photographs of her, including a sensational portrait depicting her with three pairs of eyes—an effect he achieved through multiple exposures. That photograph was Man Ray's breakthrough: "The picture of the Marquise went all over Paris; sitters began coming in—people from the more exclusive circles, all expecting miracles from me," he wrote. The rising Elsa Schiaparelli, who was running a salon boutique near the Hôtel du Rhin, where Luisa Casati was lodging, also hoped for a breakthrough. In order to win over the marchesa as a customer, the designer sent one of her employees to the Hôtel du Rhin with a gift. As Elsa Schiaparelli later reported in her autobiography, *Shocking Life*, Casati received it, unimpressed, "covered with a rug of black ostrich feathers, eating a breakfast of fried fish and drinking straight Pernod while trying on a newspaper scarf."

No business relationship between the two Italians ever developed. The functionality of Elsa Schiaparelli's early creations simply did not suit the opulent wardrobe of the marchesa. Nevertheless, Luisa Casati was becoming an exotic outsider in Paris. After she moved to the Palais Rose, beyond the city gates, she downsized her private zoo, loaning out the two Bengal tigers with which she had impressed guests at her soirees and her favorite big cat, a black panther named Toto, who had been stuffed and outfitted electromechanically. Even her appearances at de Beaumont's masked balls no longer achieved the desired effect. An effort to relive her great success of 1922, when she appeared at the Bal vénitien as the "Queen of the Night" in a diamond costume designed by the stage designer Léon Bakst, was a failure. When the dress, which was completely covered with lightbulbs, was switched on, "the costume was short-circuited, and, instead of being lighted up with a thousand stars, the Marquesa suffered an electric shock," according to the photographer Cecil Beaton. It was a catastrophe that would be repeated the following year during another of de Beaumont's balls, this time staged by Pablo Picasso. Casati came wrapped in a Cubist mesh of wires and lamps.

Paris was an expensive city, even for the marchesa. Her soirees in the Palais Rose,

her lavish social appearances and extensive shopping tours in her black Rolls-Royce, caused her considerable wealth to shrink, bit by bit. In order to avoid bankruptcy, Luisa Casati sold her homes in Rome and Milan, which initially gave her another opportunity to spend freely, and to organize an especially splendid costume party dedicated to the Italian occultist Alessandro Cagliostro in June 1927. Because it was to begin at night, light-reflecting shields were set up over several kilometers to guide the guests to the palais. The ball became the largest and most expensive party Luisa Casati threw in all her time in Paris, and also the last one on a similar scale. Her obligations grew, and in order to meet them she ultimately sold parts of her palace inventory at prices well under their value. Smaller creditors, such as grocers and taxi drivers, were paid with high-quality jewelry. In 1932, the marchesa was heavily in debt, and the rest of her assets had to be auctioned off. She moved into a small apartment on the quai de Bourbon. It was an unspectacular end to her career as a diva who, for more than a decade, lent Paris a highly individual splendor. "I prefer her unicorn's horn, stuffed boas, bronze hinds, and mechanical tigers," Jean Cocteau wrote in his memoirs, "to the nice little audacities of fashion and that good taste which puts yesterday's bad taste on a pedestal and radiates nothing mysterious or significant."

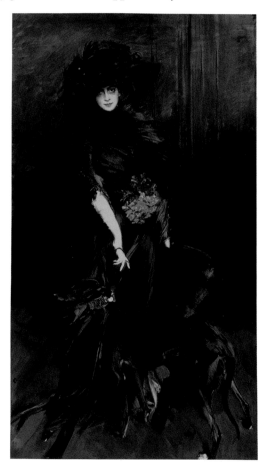

Portrait of the Marchesa Luisa Casati with greyhounds by Giovanni Boldini, 1908. Private collection.

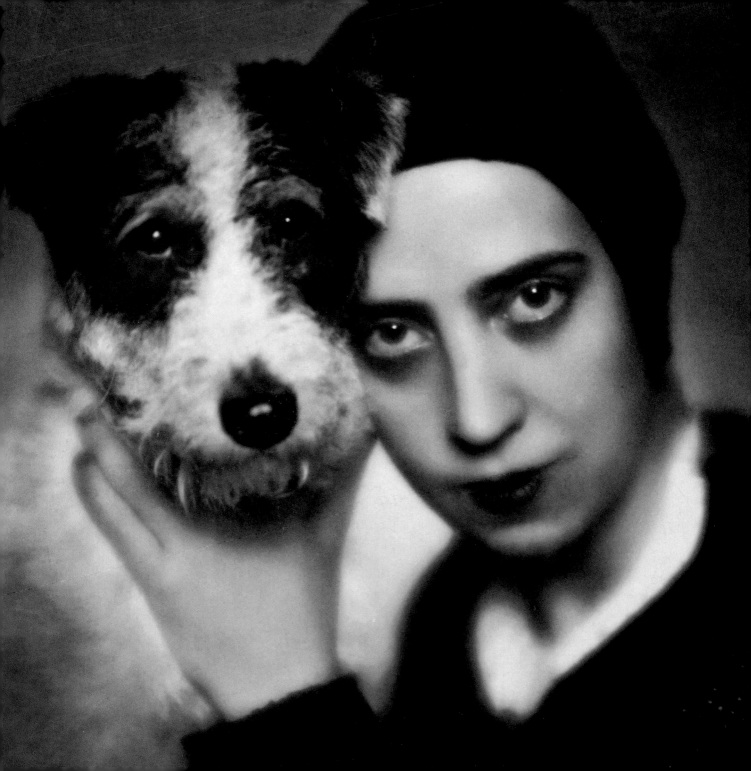

ELSA SCHIAPARELLI

1890–1973

*Many people have written that I started in business sitting
in a window in Montmartre and knitting. In fact I hardly knew
Montmartre and I have never been able to knit.*
—Elsa Schiaparelli

When Elsa Schiaparelli opened her most splendid fashion salon in Paris in the mid-1930s, on the place Vendôme, opposite the Ritz, decorated with works by Alberto Giacometti, it put to rest any lingering questions about the marketability of her extravagant creations. Already in 1927, a good decade before her famous collection that drew on motifs from Salvador Dalí and Jean Cocteau, the Italian couturier had recognized the potential of Surrealism for fashion and was the first designer to employ it in her creations. Still working in her studio on the rue de la Paix, Schiaparelli started doing business with avant-garde jewelry designer and writer Elsa Triolet, having been delighted by her unique "colliers de Paris." Triolet and her jewelry had been given the brush-off by all the established retailers. One of the rejected items, a necklace of aspirin tablets, would become a moneymaker for Elsa

Elsa Schiaparelli. Photograph
by Dora Kallmus, 1920.

Schiaparelli. "I was annoyed," Triolet recalled, "that the other houses, without exception, detested their successful and innovative competitor Schiaparelli and did not leave me in peace: 'You can take that to Schiaparelli; that is her style; elegant women don't wear such things. . . . Only women of the world buy their clothes from us. . . . That is American chic in Schiaparelli's style. . . . Better you work for her. . . . That was how they set me straight at the big houses or just turned me out." In the end, this would turn out to suit Elsa Schiaparelli just fine, since the widespread tendency of haute couture to dismiss the newcomer gave her an advantageous exclusivity. "Please be so kind as not to show the models you bring me to anyone else first," she instructed Triolet and asked her to use the rear entrance in the future. She did not want word to get around that Triolet's unusual necklaces were not created by the house of Schiaparelli itself.

Schiaparelli's eye for innovation was based on a distinct sense of beauty and the joy she took in offbeat ideas. She was born in Rome to an intellectual family of the grande bourgeoisie. In her autobiography *Shocking Life*, she recalls placing the seeds of flowers in her ears, throat, and nose, believing this would make her beautiful someday. At the age of fifteen, she "shocked" her parents again by publishing erotic poems. As a young adult, she moved to London to escape the advances of an insistent admirer. Initially she worked as a nanny. But in 1916, she and theosophist Wilhelm de Wendt de Kerlor, whom she had married two years earlier, moved to Greenwich Village, the renowned bohemian neighborhood of New York City. De Kerlor hoped to find better working and living opportunities there, while Elsa spent time with husband-and-wife artists Gabrielle and Francis Picabia, Marcel Duchamp, and Man Ray. Ultimately, Elsa's theosophical playboy turned out to be a "impoverished spendthrift," and the marriage only lasted until the dowry had been spent. Shortly after the birth of their daughter, Gogo, in 1920, de Kerlor left her. "Few people," she recalled, "have been so deeply hurt in their feelings or so cruelly wounded in their pride."

In 1922, Elsa Schiaparelli decided to start over in Paris. She and Gogo initially lived with Gabrielle Picabia, who moved to Paris too and helped Schiaparelli start over. A wealthy New York girlfriend paid the costs of the young mother's transatlantic journey. In the metropolis on the Seine, Elsa Schiaparelli designed her first dresses, initially for Gabrielle Picabia. For a time, Schiaparelli kept her head above water by serving as

a guide for American tourists. During a salon party on the rue du Faubourg Saint-Honoré, she met Paul Poiret, the host of the event. The meeting would prove advantageous for Schiaparelli. The grand seigneur of haute couture encouraged her to let her creativity run free on the fashion scene in Paris and to try to work as a designer. Soon thereafter, Schiaparelli, a goal-oriented autodidact, was selling her designs— primarily for knitwear—to several fashion houses. In 1925, she was hired as a designer by the renowned Maison Lambal. Her very first collection, which she had developed in her apartment on the rue de l'Université, ended up in *Vogue* in early 1927: the photographs of three pullovers, whose patterns had been inspired by the Bauhaus, were simply captioned "Schiaparelli." The photos were by George Hoyningen-Huene, the most prominent photographer at *Vogue*.

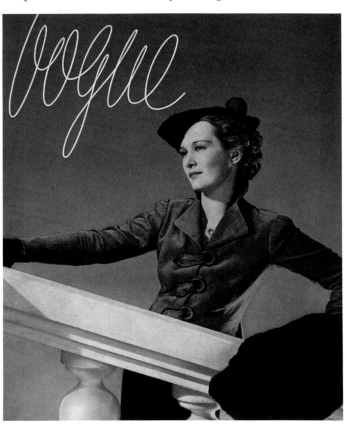

Schiaparelli fashion in *Vogue*, 1935.

This first success was considerable, but it was nothing compared to that of the collection that followed.

It was at a "smart lunch" in 1927 that she first impressed several greats from the fashion industry with a black pullover with a knitted-in white bow. This design was presented publicly shortly thereafter, and it went on to revolutionize the fashion of the 1920s. The sweater with the Surrealist trompe-l'oeil motif became an unprecedented success: "All the women wanted one, immediately," she recalled. Both the American and the French *Vogue* credited her with having created an "artistic masterpiece." Schiaparelli had already sought out artistic circles in her New York period, and in Paris, her contacts with the Surrealist avant-garde intensified. In addition to Man Ray, Cocteau, Dalí, Louis Aragon, and Elsa Triolet, Schiaparelli befriended Nancy Cunard—who was one of the first to purchase the sensational bow pullover.

She slapped Paris. She smacked it.
She tortured it. She bewitched it.
And it fell madly in love with her.

—Yves Saint Laurent

"The Italian artist who makes clothes," as her competitor Coco Chanel called her somewhat disparagingly, had achieved her breakthrough in Paris. An American businessman immediately ordered forty of the handmade pullovers along with matching crepe de chine skirts. Elsa Schiaparelli hired a number of knitters and seamstresses in order to fulfill the contract on time. This was just the beginning. In late 1927, she

moved into a spacious atelier on the rue de la Paix, in which she was soon designing for stars such as Greta Garbo, Joan Crawford, and Katharine Hepburn. "Pour le Sport" was the message on the front door to her salon. For all the originality and extravagance of her designs, comfort was crucial for Schiaparelli. In the years that followed, she developed ski, tennis, and swim clothing for women. Her clothes emphasized the body but permitted free movement of the limbs. The same was true of her collection of evening wear, as in the legendary black dress of ciré satin worn by model Bettina Jones and photographed by Hoyningen-Huene. The cut of a dress always had to be based on the woman's body. That principle made Schiaparelli's creations uncommonly popular. In 1930, just three years after the big hit she had with her bow pullover, Elsa Schiaparelli had four hundred employees on the rue de la Paix. Her formula for success was ultimately very simple: "I kept in touch with the needs of women who had confidence in me and tried to help them find their type."

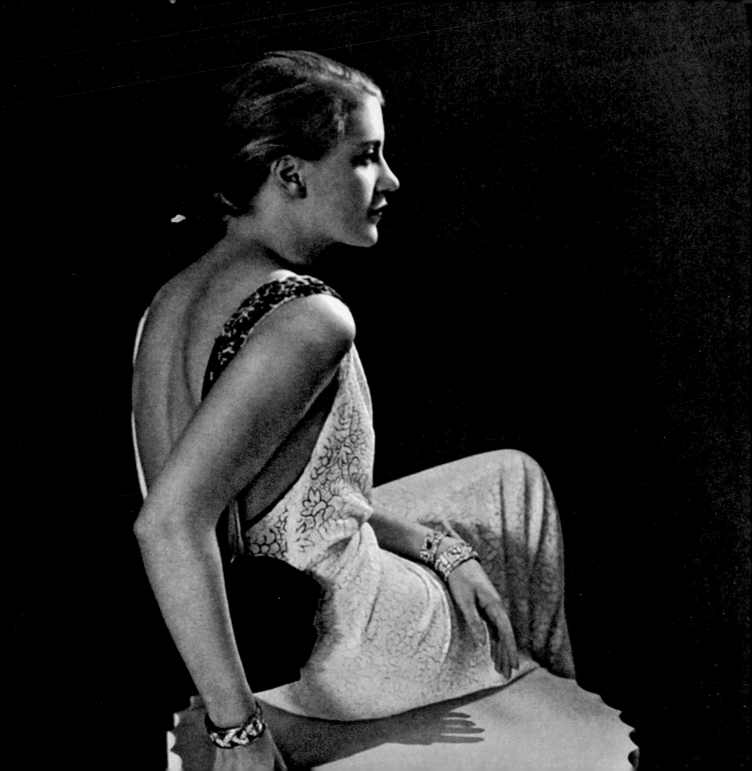

LEE MILLER
1907–1977

*Only sculpture could approximate the beauty of her curling lips,
long languid pale eyes and column neck.*

—Cecil Beaton

Lee Miller's first encounter in the summer of 1929 with Man Ray, the star photographer of the Parisian art scene, is legendary and would point the way forward for the Surrealist movement. Miller, in her early twenties and a model as successful as she was desired, was carrying letters of reference from the prominent New York photographer Edward Steichen and *Vogue*'s publisher, Condé Nast, when she stood unannounced in front of Man Ray's studio apartment in Montparnasse. From his concierge she learned that he was on his way to the south of France, whereupon she set off, dejected, for his local bar, the Bateau Ivre on the place de l'Odéon. Drinking wine and chatting with the Russian owner of the bar, she finally spotted Man Ray, emerging as if from the void, climbing the narrow spiral staircase to the upper floor. "He looked like a bull," as she told it later, "with an extraordinary torso and very dark eyebrows and

Lee Miller in an evening dress by Lanvin, 1932.
Photograph by George Hoyningen-Huene.

dark hair. I told him boldly that I was his new student. He said he didn't take students, and anyway he was leaving Paris for his holiday. I said, I know, I'm going with you—and I did." Lee Miller's relationship, private and professional, with Man Ray, who was seventeen years older, lasted for three years and marked the turning point in her career from model to photographer.

As a model, Lee Miller was already a star. She impressed the fashion photographers of New York with her unapproachable radiance and her talent for standing in front of the camera, lost to the world, almost as if in a trance. Her career actually began with a lucky coincidence. In 1926, enrolled at the Arts Students League in New York, the nineteen-year-old from Poughkeepsie moved into a brownstone near Fifth Avenue and plunged headfirst into the colorful scene of this East Coast metropolis. Trying to cross the busy street, Miller was nearly hit by a car, and the person who then carried her back to the sidewalk happened to be the publisher of *Vogue*, Condé Nast. He was simply fascinated by the charismatic beauty who fell into his arms so suddenly, and who perfectly represented the "classic chic" that distinguished his magazines. So, just a short time later, on March 15, 1927, Lee Miller ended up on the cover of *Vogue* for the first time, drawn by Georges Lepape, the most popular fashion illustrator of the day.

Her breakthrough as *Vogue* cover girl was followed by spectacular photographs taken by Arnold Genthe, whose early photographs of Greta Garbo had already caused a sensation, and by Nast's head photographer Edward Steichen, who made Lee Miller his favorite model. Steichen frequently photographed her in the *Vogue* publisher's thirty-room penthouse apartment on Park Avenue. Mae and Hattie Green, Lucien Lelong, Caroline Reboux, and Coco Chanel—she wore the clothes of nearly all the famous fashion designers, and now neither *Vogue* nor the many upper-class parties in Nast's refuge could be imagined without her. There she enjoyed herself with such renowned

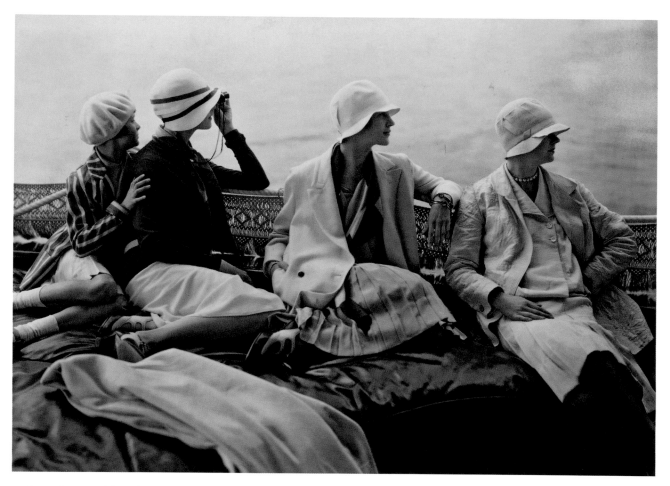

Fashion photograph by Edward Steichen for *Vogue*, 1928:
Lee Miller (second from the right) in a white flannel coat over
a two-piece dress of crepe de chine with a dark top and white
pleated skirt by Mae and Hattie Green, a scarf by Chanel, and
a white felt cloche.

guests as Dorothy Parker, Josephine Baker, Diana Vreeland, Charlie Chaplin, Fred Astaire, and George Gershwin. But looking beautiful and romping about at the parties of high society were not enough for Lee Miller over the long term. Edward Steichen, especially, had repeatedly offered her insight into the photographer's craft at their shoots together, and that gave her the idea of one day moving behind the camera. Steichen also led her to discover the work of Man Ray, who had moved from New York to Paris in 1921. And the scandal around an advertising campaign for the sanitary napkin maker Kotex, which had used a photograph of Miller without her knowledge and thus discredited her socially, probably contributed to her decision to leave New York in 1929.

Lee Miller was already very familiar with the bohemian nightlife of Montparnasse and Montmartre. When she was eighteen—four years before moving to France and her successful meeting with Man Ray—she was able to persuade her parents to let her spend her first, six-month educational stay in Paris, which she began in 1925, accompanied by two overworked governesses. They had mistakenly booked a hotel that was used as a brothel, and in retrospect Lee Miller said, "It took my chaperones five days to catch on, but I thought it was divine. I was either hanging out of the window watching the clients or watching the shoes being changed in the corridor with amazing frequency." Already at the time she was attending lectures on costume design and earning her living on the side as a guide for American tourists. After her second arrival to the Seine, that was no longer necessary; Lee Miller presented herself as a professional model, both to Man Ray and to French *Vogue*. The head photographer of the latter, George Hoyningen-Huene, was enthusiastic about Miller and included three photographs of her in the October 1929 issue. In particular, the photographs of Lee Miller in Lanvin evening dresses that the Frenchman took are among the most characteristic of that time and continue to shape her image as an icon of fashion photography. Yet these "modelling

sessions with Hoyningen-Huene," Lee Miller's son Antony Penrose tells us, were also "rather like a privileged tutorial, allowing Lee to experience the work on both sides of the camera."

Hoyningen-Huene was a genius at studio lighting, and Miller gained valuable insights into his technique. As far as the art of portrait photography was concerned, however, Lee Miller's most important mentor was Man Ray. Her erotic presence and self-assurance before the camera fascinated him. Many of the photographs Man Ray took of Lee Miller are now regarded as milestones of Surrealist photography, including various nudes, to which Lee Miller ultimately owed the reputation—initiated by the trashy magazines of the time—of having "the most beautiful navel in Paris." Together, the two developed the technique of "solarization": a particular form of double exposure that darkly contours the subject—as if surrounded by a mysterious-looking corona. Lee Miller later perfected the technique and used it to dramatize the actress Lilian Harvey.

Miller learned quickly. "I had already had some considerable professional experience fulfilling contracts and things. . . . [Man Ray] had taught me to do fashion pictures, he'd taught me to do portraits, he taught me the whole technique of what he did." Artistically, she quickly emancipated herself from Man Ray. A two-page *Vogue* article in late 1930 announced she would play the female lead in the film *Le sang d'un poète* by Jean Cocteau, Man Ray's great rival. She soon strove for financial independence as well and moved into her own studio in Montparnasse, where she photographed for Elsa Schiaparelli, Jean Patou, Coco Chanel, and others. Lee Miller also demanded her right to privacy. In 1932, she took the rich Cairo businessman Aziz Eloui Bey as her lover; his wife, Nimet Eloui, had modeled for her. Man Ray became increasingly jealous, and it is said he then got himself a revolver and demanded with threats that Lee Miller marry

him. In October 1932, she returned to New York, and Man Ray painted, as if obsessed, the painting *À l'heure de l'observatoire: Les amoureux*, which depicts Lee Miller's lips floating in the sky above Paris.

> *It seems to me that women have a bigger chance at success in photography than men. . . . And I think they have an intuition that helps them understand personalities more quickly than men.*
>
> —Lee Miller

When a magazine reporter called Lee Miller "one of the most photographed girls in Manhattan," she rebuked him with the words: "I would rather take a picture than be one." She rented a studio near Radio City Music Hall that, thanks to her popularity and her good connections to Condé Nast, remained a productive space, even during the Great Depression. Then, quite suddenly, she closed up shop, and in 1934 married Aziz Eloui Bey, who, by his own account, wanted to "bring peace to her heart." He only succeeded temporarily, but the relationship lasted a few years, and the photographs she took during her time in Egypt are now much admired examples of Surrealist photography. In 1937, Lee Miller returned Paris, where she met her future second husband, the painter Roland Penrose, at a party in the home of Max Ernst. With Penrose and his friends—including Dora Maar and Picasso, Paul and Nusch Éluard, Max Ernst and

Leonora Carrington—she attended one or another outing in the countryside, where, as the photos of that phase document, things occasionally got very permissive. Man Ray was in attendance again, this time in the company of the dancer Adrienne Fidelin. It was a lighthearted, carefree time that came to a sudden end at the outbreak of war in 1939. During the Second World War, a new career opened up for Lee Miller. She became a war reporter and photojournalist for *Vogue*. In this work, she would confirm again what *Vanity Fair* wrote in 1934: that Lee Miller was one of the "most distinguished living photographers" of the time.

PHOTOGRAPHY & FILM

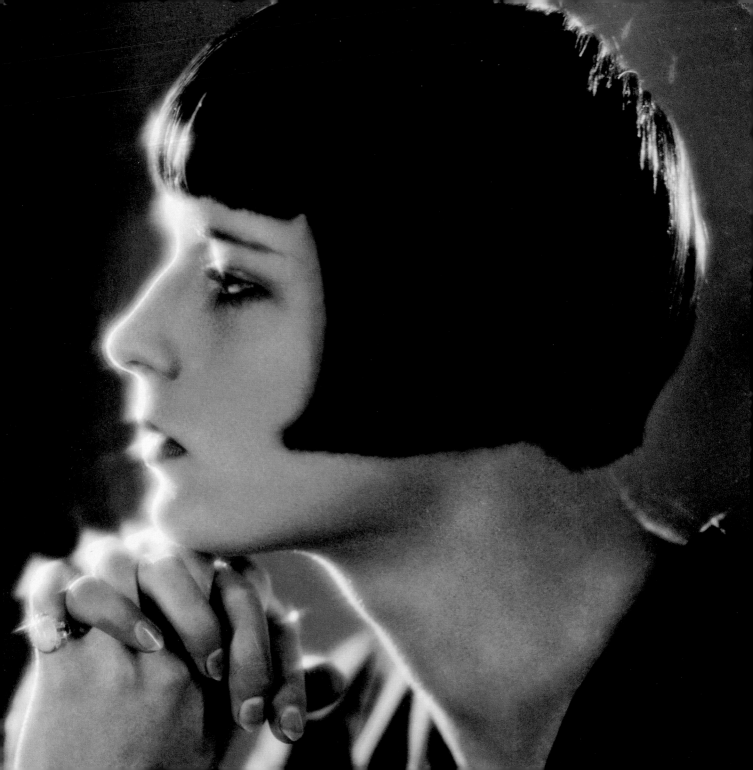

The pointed remark that Lee Miller dictated for New York journalists when she returned from Paris in 1932—namely, that she "would rather take a picture than be one"—was not merely quick-witted but purposeful: "one of the most photographed girls in Manhattan," the reporters called her, but following her successes in Paris, she wanted to be seen as an artist. Miller had been in good company on the Seine: In 1921, the American Berenice Abbott had come to the French capital and set off on highly experimental paths with her camera. Marianne Breslauer moved there from Berlin, and Germaine Krull came from Amsterdam after training at the Lehr- und Versuchsanstalt für Photographie (Teaching and Experimental Institute for Photography) in Munich and running studios in Munich and Berlin. As a medium of the avant-garde, photography was relatively new in the 1920s. Especially for creative women, photography became a means of artistic and professional self-realization. At the same time, an atmospheric, lively Paris offered them not only ideal motifs but also an outstanding network. The successful portrait photographer Florence Henri, who regularly received female students in her studio on the rue de Varenne, encouraged young talent, just as Man Ray, the head of Surrealist photography, worked with Abbott and Miller in his studio in Montparnasse and made some of his equipment available to Breslauer and Krull.

For women, photography turned out to be lucrative, especially in its ability to capture fashion and the zeitgeist: "The modern woman and the New [photographic] Vision created in the Roaring Twenties suited each other perfectly," writes the art historian Karoline Hille. Women wearing bobs or cloche hats, holding a cigarette, in a little black dress, driving a car, skiing, or playing tennis needed the new medium of photography to present their innovative look—a medium with which the women who employed it could, according to Hille, "also earn money; they were mobile and independent, creative, and artistically active." And they made names for themselves: Germaine Krull

· — 77 — ·

Louise Brooks, ca. 1929.

was soon working for the fashion designers Jeanne Lanvin, Sonia Delaunay, and Paul Poiret just as regularly as Lee Miller later would for Chanel and Schiaparelli.

Whereas fashion and art were equally important to Lee Miller and Germaine Krull, who again and again showed they could combine the two effectively in their portrait photographs, the Surrealist photographs of Claude Cahun captivated viewers with a completely different aesthetic. Claude Cahun depicted herself exclusively, playing radically with gender identities in the process. Man Ray was one of her friends, and he admired her androgynous self-presentation and her multifaceted use of mirrors, reflections, and shadows. He was one of the few who was even allowed to see her portraits at all—with one exception, Cahun never published her self-portraits.

Women are not trying to outdo the men by entering the professions. They are simply trying to do something for themselves.

—Imogen Cunningham

In the 1920s, film production companies also discovered the "high art" of portrait photography. Still photographers, who worked for Ufa in Berlin or for Paramount in Hollywood, for example, contributed substantially to the impression that celebrities made on others. Film divas were their preferred subjects: photographs of Marlene Dietrich as Lola Lola in *Der blaue Engel* (The Blue Angel), Greta Garbo as "a woman of affairs," Louise Brooks as Lulu, and Clara Bow as the "It girl" circled the globe and contributed both to the popularity of the actresses and to the spread of a new, rebellious,

and self-confident image of women. They all exemplified the flapper type—erotic flair combined with relaxed elegance—in magazines, on the screen, and in real life.

Like many other European women, Dietrich and Garbo went to Hollywood, where they were destined to receive both higher fees and greater fame. "It was not until 1930, in Hollywood ..., that I really become a star," Marlene Dietrich recalled. There was, however, also a countermovement: "In Hollywood, I was a pretty flibbertigibbet. . . . In Berlin, I stepped onto the railroad station platform . . . to meet Pabst and became an actress," wrote Louise Brooks, who, like Anna May Wong, arrived on the Spree from America and shone in artistic films influenced by Expressionism. Both for Louise Brooks and for Clara Bow, who remained in Hollywood, the dawn of the era of sound films meant the end of a career. Their art of capturing the audience's attention with gesture and, most of all, facial expression became obsolete. In retrospect, it was especially true of them what Gloria Swanson said of herself and her female comrades in film: "We didn't need dialogue. We had faces."

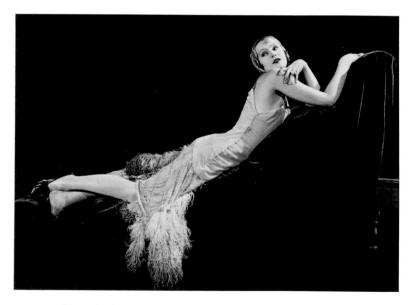

Greta Garbo in the film *A Woman of Affairs*, 1928.

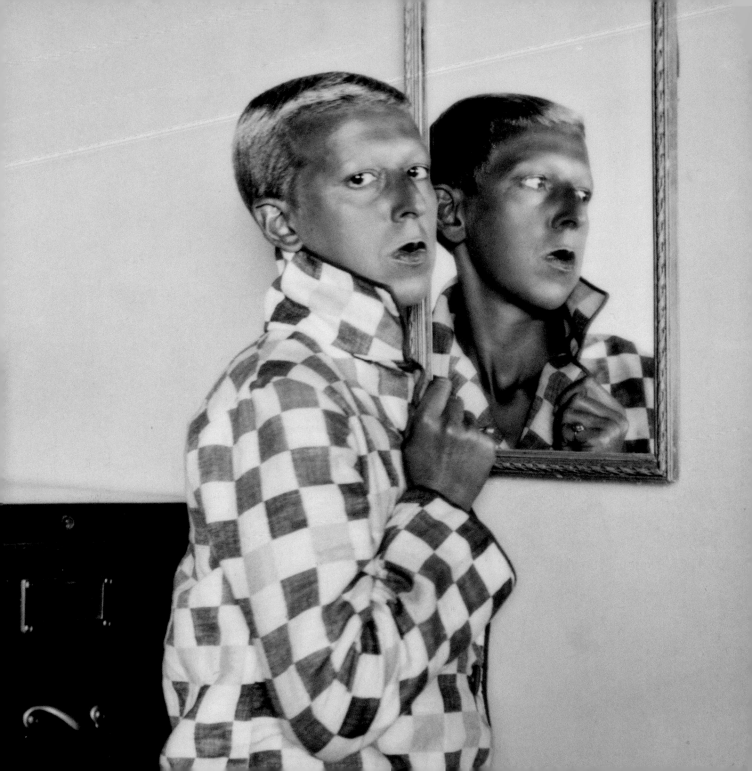

CLAUDE CAHUN
1894–1954

You know very well that I think you are one
of the most curious minds of our time (of 4 or 5)
but you willfully remain silent.
—André Breton to Claude Cahun

The astonishment of those present must have been almost palpable on that day in April 2003 when the inventory of André Breton's studio was auctioned in Paris. The print of a photograph titled *Les mains* went for 28,000 euros. Claude Cahun—"one of the greatest unknowns from the circle of the Surrealists," in the words of the journalist and philosopher Stefan Zweifel—had produced the photograph in the 1930s and given it to Breton.

At first glance, 28,000 euros might seem like an impressive price for a photograph by an artist who had appeared in public all her life primarily as a writer, not a photographer. But even before that auction, Cahun's photography had attracted the attention of art dealers and collectors. The photographs from the 1920s in particular are fascinating for their radical nature. They are highly individual documents of Cahun's mul-

Claude Cahun, *Self-Portrait*,
gelatin silver print, 1928.

tifaceted understanding of freedom—and remarkably diverse, even though until 1930 the photographer had only one motif: herself.

Claude Cahun was an outsider in art and in life. Already at school in Nantes, this daughter of a family of publishers and intellectuals was picked on by her fellow students for her Jewish origins. So her father sent her to a school in the English county of Surrey for two years, where her interest in literature, and especially in the works of Oscar Wilde, developed. In 1914, she began to study philology at the Sorbonne and published her first texts. Six years later, she and her life partner, the graphic artist Suzanne Malherbe, settled in Montparnasse. Malherbe was also her stepsister: Cahun's father had remarried after his first wife, Cahun's mother, was permanently committed to a psychiatric clinic. In an apartment on the rue Notre-Dame des Champs, the couple launched a meeting of artists and writers that became, like the salon of Gertrude Stein and Alice Toklas, a favorite meeting place for Parisian bohemians and intellectuals. The booksellers and publishers Adrienne Monnier and Sylvia Beach were among the guests, as well the writers Henri Michaux and Philippe Soupault, the editor of the popular Surrealist organ *Littérature*.

From the time she moved to Montparnasse, Luc Schwob was appearing exclusively under her alias: Claude Cahun. This pseudonym was intended to convey gender neutrality but was also an homage to Claude's great-uncle, the writer Léon Cahun. Claude Cahun quickly made a name for herself on the literary and lesbian scene of Paris. She published articles in avant-garde magazines in which she advocated for freedom of sexual orientation, as well as a collection of novellas, *Héroïnes*, a feminist interpretation of legendary female figures such as Salome, Sappho, and Gretchen as Goethe's *Faust*. "My opinion on homosexuality and homosexuals," Claude Cahun revealed to the readers of the journal *L'amitié* in 1925, "is exactly the same as my opinion on heterosexuality and heterosexuals; everything depends on the individuals and on the circumstances.

I uphold people's rights to behave as they wish." In addition to her journalism, the photographs she was taking at the same time became indicators of her liberal thinking. Claude Cahun cut her hair short and posed in a sailor's outfit, in a confirmation suit, as Buddha seated in a lotus position, and as a circus strongman with her lips puckered. "Behind this mask another mask, there can be no end to these disguises"—such was her concept of artistic self-transformation. For a series of portraits taken in 1928, ironically christened by the photographer as "my monstrosities," she even shaved her head—as the ultimate means of androgynous self-presentation.

Claude Cahun published only one photograph in the 1920s. It was one of her "monstrosities," and it appeared in the journal *Bifur*, in 1929, under the title *Frontière humaine*. Most of her self portraits were shown in smaller, less formal venues: Parisian bookstores, for example, or privately in her salon to friends and acquaintances. Claude Cahun expressed herself only very guardedly, if at all, about the character of her photographs as works of art. "We are left from before the war," she wrote her friend Charles-Henri Barbier in 1952, "with rather beautiful photographs. Beautiful? Yes, if I may judge from

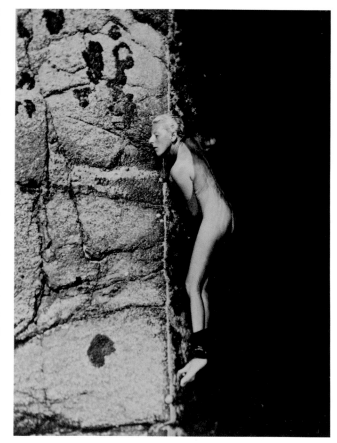

Claude Cahun, *Self-Portrait*, ca. 1928. Her photographs always reflected an androgynous ideal and strove to overcome separation of the sexes.

the diversity of those who have admired them . . . , strangers who were exposed to them in bookstores, . . . and the appreciation of a few who saw them at our place. Among the latter, from people who are not aesthetes at all to professionals such as Man Ray."

As far as the depiction of this type of liberated woman is concerned, Claude Cahun was without a doubt one of the most courageous of the women photographers of her time. In the 1930s, her social engagement expanded to other spheres of activity. From 1932 onward, she supported—without becoming an official member—the leftist, pacifist Association des écrivains et artistes révolutionnaires that formed around Breton and Max Ernst, to which, among otheres, the designer Charlotte Perriand belonged. In 1935, Cahun was a founding member of the antifascist artists' group Contre-Attaque and appeared publicly with Surrealist photographs of objects; now she only took self-portraits occasionally. In 1940, she followed up her artistic activism with political activism, co-organizing with Suzanne Malherbe on the channel of Jersey, to which they had moved in 1937, the resistance to German occupation—with a wealth of ideas and at considerable risk to their lives. From their country home, La Rocquaise, the couple distributed anti-German, collaged leaflets, inserting them in Nazi-controlled newspapers. On the local church spire, they raised a flag with a message that could be seen from afar: "Jesus died for the people, but the people are dying for Hitler." It took four years to identify the authors of that action. The two inconspicuous, sickly women, always dressed in black, that they pretended to be were not suspected by anyone for a long time. It was surely the most courageous of Claude Cahun's many masquerades. In late July 1944, she and Malherbe were exposed and arrested—too late, fortunately: the death sentence imposed on them was never carried out, and they were released from custody in early 1945.

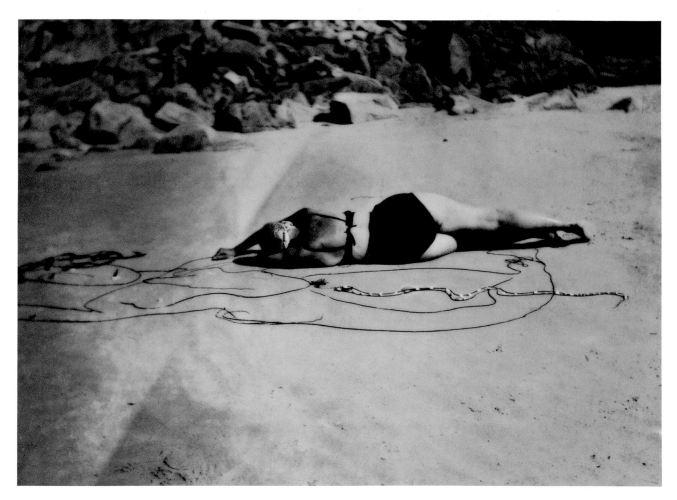

This self-portrait, ca. 1930, is part of a series.
Lying next to Cahun in the sand is a black rope
from which she appears to have freed herself.

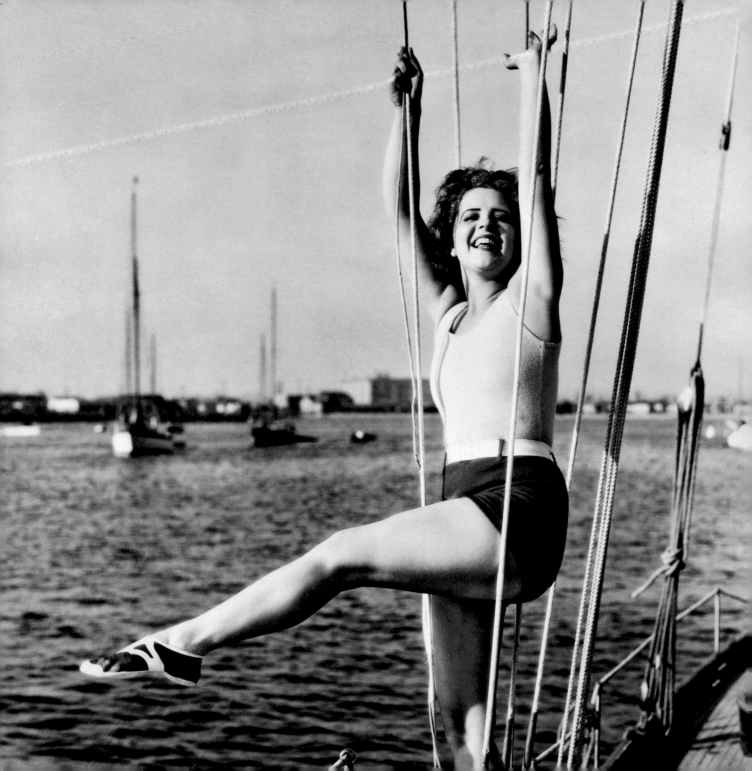

CLARA BOW
1905–1965

We had individuality. We did as we pleased.
We stayed up late. We dressed the way we wanted. . . .
Today, they're sensible and end up with better health.
But we had more fun.

—Clara Bow

The quirkiest of Hollywood's film divas was at the same time the hardest working: in 1925 and 1926 alone, Clara Bow performed in twenty-two films and attracted attention as much for her numerous flirtations and affairs on the set as for her acting talent. Nevertheless, she had yet to become a star of the magnitude of Gloria Swanson or Colleen Moore. Ben Schulberg, the producer of her films and a force in Hollywood, was one of the first to recognize the potential of the young actress from New York and launched an image campaign intended to establish Clara Bow at Paramount as "the hottest jazz baby in films." Thanks to major roles in the films *The Plastic Age* and *Dancing Mothers*, her popularity began to rise, but her career only really got going when Schulberg introduced her to the scriptwriter Elinor Glyn. Glyn was searching for the ideal leading woman for her new story *It* and promptly found her: "It'

A radiant Clara Bow on a sailboat, 1929.

is an inner magic, an animal magnetism," she explained to Clara Bow, holding her head between her hands, looking deep into her eyes. "You are my medium, child." Shooting for *It* lasted just over a month. After the movie premiered, Clara Bow was *the* Hollywood sex symbol and one of the greatest American silent film stars—and she inspired the phenomenon that owes its name to her role and is still with us today: Clara Bow was the first "It girl" in history.

Clara Bow is the quintessence of what
the term 'flapper' signifies.

—F. Scott Fitzgerald

At sixteen, the self-confident, capable Clara from the slums of Brooklyn secretly signed up for the Fame and Fortune Contest of 1921, organized and sponsored by *Motion Picture* and other film magazines. When her psychologically disturbed mother heard about it, she threatened Clara with a butcher knife. Luckily she managed to escape and was soon able to leave her sad childhood behind—as winner of the competition, she got a role in a film. In 1923, Clara Bow went to Hollywood, where Schulberg put her under contract, and that same year she shone in a minor role in the film *Black Oxen*, directed by Frank Lloyd. Lloyd was enthusiastic about the stage talent of the newcomer from Brooklyn and saw her as the "personification of the . . . flapper," who was also "mischievous, pretty, aggressive, quick-tempered and deeply sentimental," as he told the *Hamilton Evening Journal* in March 1924. That sparked a competition between Clara Bow and her rival Colleen Moore that would continue for years. Moore was already a star at that point, and since the film *Flaming Youth* of 1923 she had been celebrated

as the ultimate actress for flapper roles. She embodied the rather sober, boyish-androgynous type, which inevitably contrasted with Clara Bow's sensuousness personified. The competition between the two ultimately led to a fight during the shooting of the film *Painted People*: Worried that Clara Bow would steal the show, Colleen Moore forbade the director to shoot close-ups of her competitor. Bow protested furiously, but Moore had the upper hand—the film's producer, John McCormick, was her husband. Bow ultimately forfeited her fee and quit; McCormick had to find another actress.

Colleen Moore's jealousy stemmed from her fear that she would lose her role as Hollywood's star flapper. For audiences of the time—and many professionals in the film

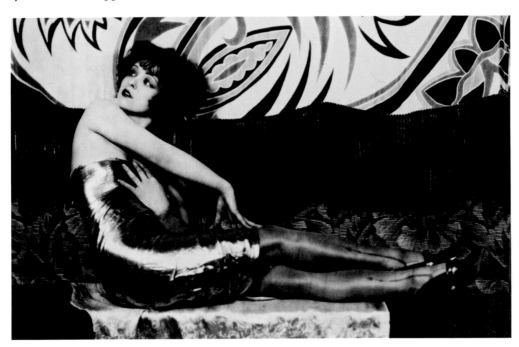

Clara Bow in the 1920s.

industry—Clara Bow had something that Moore lacked in comparison to her rival: sex appeal. "All she had to do was lift those lids and she was flirting," said the cameraman Arthur Jacobson, who was Clara Bow's lover for a time—just one of many who praised the erotic presence of the actress. Her casting call with Ernst Lubitsch was legendary: she misread his tic of constantly pursing his lips as flirting, and responded by blowing kisses. It goes without saying that she got the role, and became the cover girl of the film

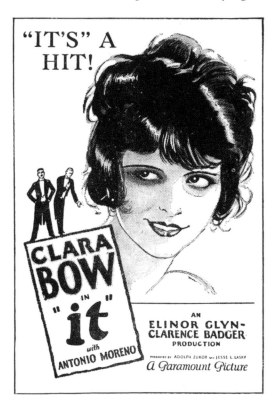

The poster for *It*, 1927.

magazine *Motion Picture Classic*, who published a long story about her under the title "The Kid Who Sassed Lubitsch." The director William Wellman, with whom she made the successful film *Wings* in 1927, recalled that "all the young actors . . . fell in love with Clara Bow, and if you had known her, you could understand why." Camera operators, lighting crews, and others on the set appreciated the actress because she never denied her common origins, was uninterested in the affectations of stars or high society etiquette, and liked to amuse those present with anecdotes told in coarse Brooklyn slang. She was authentic and played the flapper roles of her films in real life as well. Her earnings, in which Schulberg also substantially partook as her agent, flowed freely from her hands: when driving her Kissel convertible through Los Angeles, her favorite destinations, along with bars and restaurants, were the gambling dens of the city. She called the living room of her apartment on Hollywood Bou-

levard her "loving room" and received there, among others, the director Victor Fleming, who was one of her greatest admirers, though she rejected his marriage proposal. "Marriage ain't woman's only job no more," she told the columnist Dorothy Manners. "A girl who's worked hard and earned her place ain't gonna be satisfied as a wife." Her views of marriage were more modern than those of the character who would ultimately make her famous in 1927: *It* tells the story of the energetic factory worker Betty Lau, who with wit, cunning, courage, and the deliberate application of her sensuality—all of which added up to "it," the "certain something"—ignores class barriers and conquers the heart of her wealthy junior manager and ultimately leads him to the altar. The end of the film leaves no doubt that Betty Lau, even after the marriage, is the one who makes the rules. *It* became one of the biggest box office hits of the 1920s and made its leading woman a symbol. "This Bow girl certainly has that certain 'It' for which the picture is named," the magazine *Variety* judged, and Scott Fitzgerald said, after seeing the film, "Clara Bow is the quintessence of what the term 'flapper' signifies."

In contrast to the main character in the film, Clara Bow did not have a keen nose when it came to her own relationships. Gary Cooper, for example, with whom she had an affair after her great success with *It*, turned out to be a mama's boy: his parents saw Clara Bow as a magnet for scandal and publicly declared—in their son's name—the affair to be over. "The more I see of men, the more I like dogs" was one of the actress's popular bons mots about her countless failed love affairs. After the film *Wings*, *It* remained the biggest success of her career, which, with the rise of the sound film, came to an early end—accelerated by a smear campaign in the trashy magazines claiming she had seduced an entire football team, which cost her several roles. The silent film audience had waited hand and foot on the It girl and remembered her as fondly as the It author, Elinor Glyn, did: "Of all the lovely young ladies I've met in Hollywood, Clara Bow has 'It.'"

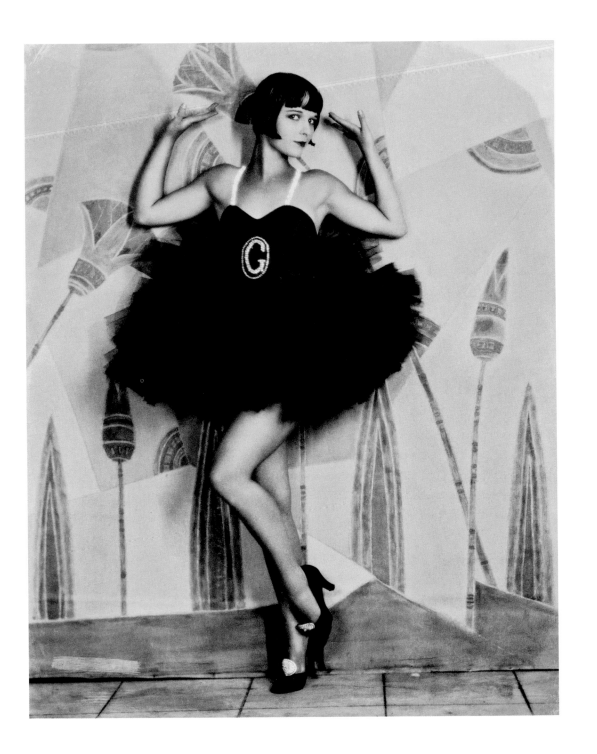

LOUISE BROOKS
1906–1985

In Hollywood, I was a pretty flibbertigibbet. . . .
In Berlin, I stepped onto the railroad station platform . . .
and became an actress.

—Louise Brooks

The "shiny black helmet"—that was the catchy metaphor Louise Brooks always used to describe her unmistakable hairstyle. According to her autobiography, *Lulu in Hollywood*, the stylish haircut was inspired by her flapper friend Barbara Bennett as they were strolling together through Manhattan one day: "We lunched on chocolate milkshakes at a drugstore," Louise Brooks recalled, "after which she took me to the smart hairdressing shop of Saveli, where Saveli himself attended to my hair. He shortened my bangs to a line above my eyebrows, shaped the sides in points at my cheekbones, and shingled the back of my head. Barbara was pleased. 'As a mat-tra-fact, Pie-Face,' she said, 'you are beginning to look almost human.'" The two budding actresses were just sixteen when they left home at the same time in 1922 to conquer the Big Apple. For Louise Brooks, success came quickly, not only because of the magic of

Louise Brooks in the film *Now We're in the Air*, 1927.

her perfect face—a face still discussed by film historians today—and her gleaming eyes beneath her shiny black bob. It was her wit, her intelligence, her ability to be self-ironic, and her determination not to buckle under the pressure of the American film industry that won over her contemporaries.

The adventurous girl from an upstanding home owed her training as a dancer to the the Denishawn School of Dancing, located in the basement of a church on Broadway. For two years, Louise Brooks held out there, and then she quit the troupe and decided to stand on her own two feet. In 1924, she gave notice on her room on Riverside Drive and moved into the trendy Algonquin Hotel—where Dorothy Parker was also staying—and began work as a chorus girl in the Broadway revue *George White's Scandals*. The house composer at the time was George Gershwin. In Manhattan's smart set, especially among the younger Wall Street brokers, the "most eligible bachelors in their thirties, finding debutantes a threat, turned to pretty girls in the theater, whose mothers weren't husband hunting," Brooks recalled. Among these young dancers, Brooks caused quite a stir. Soon she had to leave the Algonquin: Frank Case, the manager of the hotels, kicked her out after she upset several of his guests by wearing an especially short dress. This "humiliating eviction" was an experience that nagged her and from which she finally gained distance only by taking a vacation in London with Barbara Bennett. The trip almost never happened. Just seventeen, Louise Brooks was officially too young to be issued a passport. "But I wept quite pitiful black mascara tears for the passport man," she said. And it worked. She got her passport and traveled with Bennett to the British capital in late 1924, where she became one of the first women to dance the Charleston in the trendy Café de Paris on Coventry Street.

Brooks's career—and her private life—really commenced after her return from London. In 1925, she was given a solo dance number in the Ziegfeld Follies, landed her first minor film role, and modeled for the cover of *Art & Beauty Magazine*. She

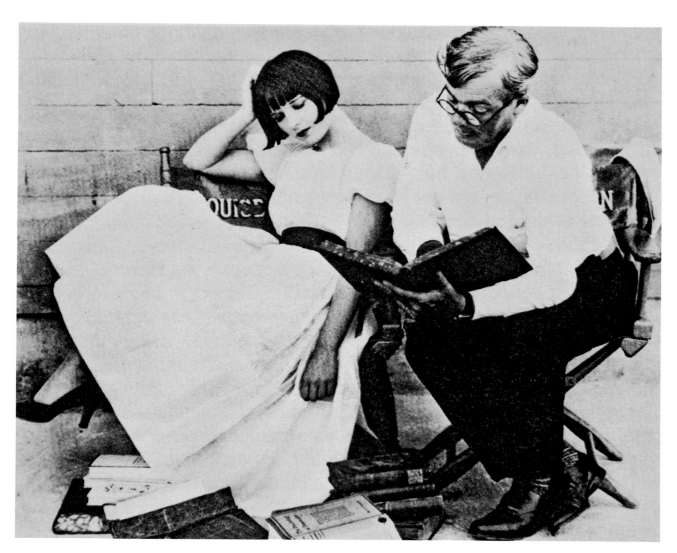

The actress Louise Brooks at work, ca. 1920.

moved to Park Avenue, had a stormy affair with Charlie Chaplin, and finally married the director Edward Sutherland. Paramount Pictures offered her a contract for five films in 1926, for which Eugene Robert Richee, a photographer at Paramount, took a legendary series of promotional photographs of the actress against a black backdrop. To this day, his photos contribute to Brooks's reputation as an icon of both film and modeling in the Jazz Age.

In the comedy *Love 'Em and Leave 'Em*, Brooks won over the press without exception. *Variety* magazine claimed she had acted better than Evelyn Brent, the female lead in the film. She ultimately gained prominence thanks to the Hollywood productions *Beggars of Life* by William Wellman and *A Girl in Every Port* by Howard Hawks, in which she stood out not only for her acting abilities but also for a sensational leap into a pool from a dizzying height. The fact that she was offered only comedy roles—several probably only because her better-known competitors, Lillian Gish and Clara Bow, were already engaged elsewhere—caused her to be rather reticent about her status as a film star and to regard it with a great deal of irony. For American filmmakers, who generally preferred to cast blondes in leading roles, Brooks was nothing more than a "brunette blonde" who was from the outset placed, as she modestly expressed it, "in the category of 'beautiful but dumb,' where I remained to the end of my film career."

The role that immortalized Brooks as an easygoing Jazz Age girl, and that contributed to her reputation as an artist, was offered to her by the director Georg Wilhelm Pabst. For months, he had been searching for the ideal actress to cast as the sensuous Lulu for his screen adaptation of Frank Wedekind's drama *Die Büchse der Pandora* (Pandora's Box). He had almost engaged Marlene Dietrich when he saw Louise Brooks in one of her Hollywood films and immediately sent a telegram to America. "Imagine," Dietrich supposedly said to a Paramount costume designer later, "Pabst choosing Louise Brooks for Lulu when he could have had me!" To Pabst, Brooks's acting abilities

mattered more than her flapper image. In his view, she conveyed naïveté—indispensable for the character of Lulu—primarily as an actress and not necessarily as a person. "In Hollywood," as Louise Brooks saw it, in any case, "I was a pretty flibbertigibbet. . . . In Berlin, I stepped onto the railroad station platform to meet Pabst and became an actress."

Louise has a European soul.
You can't get away from it.

—Georg Wilhelm Pabst

When Louise Brooks arrived at the Berlin Zoo train station in October 1928 with her lover, the New York businessman George Marshall (her marriage to Edward Sutherland had lasted only two years) shooting in Babelsberg began that same day. It lasted a good month and a half, but during that time her work did not cause her to neglect pleasure. Louise Brooks was fascinated as she mixed with the night owls of the Berlin scene, whose licentiousness surprised her: "The nightclub Eldorado," she wrote, "displayed an enticing line of homosexuals dressed as women. At the Maly [nightclub], there was a choice of feminine or collar-and-tie lesbians. Collective lust roared unashamed at the theater. In the revue *Chocolate Kiddies*, when Josephine Baker appeared naked except for a girdle of bananas, it was precisely as Lulu's stage entrance was described by Wedekind: 'They rage there as in a menagerie when the meat appears in the cage.'" The multifaceted nightlife of New York seemed to her comparatively fussy.

After working with Georg Wilhelm Pabst a second time—on the film *Tagebuch einer Verlorenen* (Diary of a Lost Girl), she played the lead in the Parisian production *Prix de*

Beauté (Beauty Prize) in 1929. The author René Clair wrote the screenplay, and the Italian Augusto Genina directed. Both *Prix de Beauté* and *Die Büchse der Pandora* were, like many other European silent films, strongly inspired by Expressionism, and for that very reason, Louise Brooks was a perfect fit. As the film historian Peter Cowie has explained, "Black and white were the colors of Expressionism and suited Louise beyond any other. First Pabst, and then Augusto Genina, instinctively emphasized the raven black of her hair and the cream white of her face and neck and arms." The French fashion designer Jean Patou designed the costumes for *Prix de Beauté*. His creations suited the actress especially well, and were a crucial factor in numerous European fashion magazines printing photographs of her. Of course, American magazines published her too. One of the most characteristic examples, still frequently reproduced today, was taken by Edward Steichen in 1928 for the magazine *Vanity Fair*, which again praised her "sultry Cleopatra bangs" in the caption.

Reversing the trend that brought many actresses—such as Marlene Dietrich and Pola Negri of Poland—from Berlin to America at the height of their fame, Louise Brooks went from Hollywood to Europe. *Die Büchse der Pandora* was considerably more successful there than in her native country, where the film was released in cinemas just after the New York stock market crashed. Brooks's popularity ended with the era of silent film. Although she appeared in sound films until 1938, her star faded just as her hairstyle fell out of fashion—especially since the self-described "most completely passive actress in the world" made no effort to establish contacts with Hollywood filmmakers. In America she fell largely into oblivion until the journalist Kenneth Tynan dedicated a long essay to her in the *New Yorker* in 1979 titled "The Girl in the Black Helmet," which would ring in a kind of Brooks renaissance. Tynan appreciated especially her achievement in *Die Büchse der Pandora* and praised, among other things, the way Brooks appeared to merge her personality almost completely with the role. An

article that appeared in the London film magazine *Sight & Sound* in 1958 illustrates this. The director Georg Wilhelm Pabst is credited with having presented the ultimate Lulu character in 1928, "in a unique frame of black and alabaster beauty, totally unlike whatever quality of sexual charm any other star in the world had ever brought to the screen."

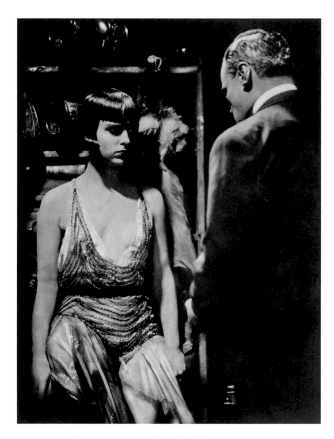

A scene with Fritz Kortner from the film
Pandora's Box by Georg Wilhelm Pabst, 1929.

CABARET & DANCE

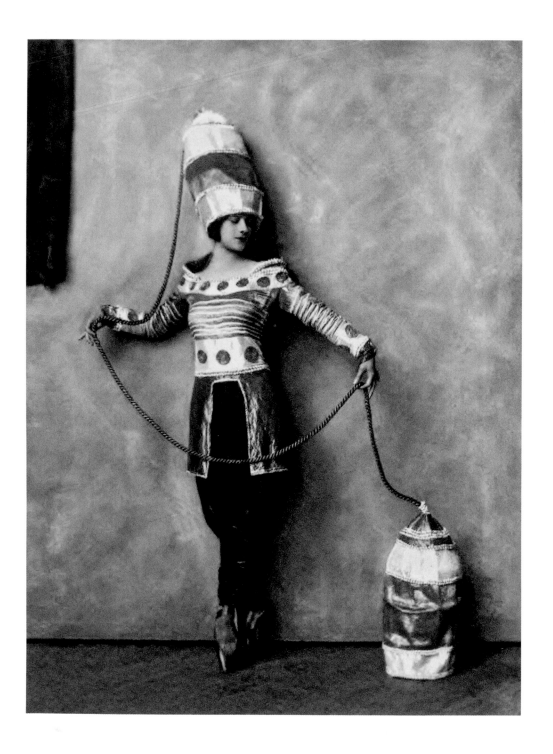

The impression that Louise Brooks got of the heated Berlin scene during her guest performance on the Spree was not inaccurate. It had been booming since the early 1920s: dance stages and cabarets were popping up like mushrooms, bars and cafés transformed every evening into dance halls, and the cellars of many restaurants became popular locations for the homosexual subculture. The famous Nelson-Theater and Rosa Valetti's Kabarett Grössenwahn (Megalomania Cabaret), both on Kurfürstendamm, were always bursting at the seams, as was the Wilde Bühne (Wild Stage) on Kantstrasse, the club Die Pyramide in Schöneberg, and later the Jockey-Club in Charlottenburg, which opened in 1929 and had a large photograph of Marlene Dietrich in tails and top hat hanging resplendent above its bar. "Millions of . . . ragingly pleasure-seeking men and women lurch and reel away in the jazz delirium," Klaus Mann reported from his own experience: "The dance becomes a mania, an idée fixe, a cult. . . . Film stars, prostitutes—all shake their limbs in gruesome euphoria. . . . It gets lively—or, rather, it gets absolutely chaotic."

In the amusement and entertainment business in Berlin, women were not just participants of equal standing; they were also protagonists of the multifaceted nightlife. "It is quite splendid, that era has ended, we are no longer playing house at the stove," Claire Waldoff sang in her legendary performances and then celebrated it afterward in her regular club—Die Pyramide—with, among others, Anita Berber when she was not stirring up the audience by dancing nude at the late-night bar Die Weisse Maus (The White Mouse). "Dancing nude became the big fashion," wrote the author and bohemian Leo Lania. "Here, in the secret bars and halls, one could participate in the vice of that era; one felt very seedy oneself."

For Anita Berber, as well as for Lavinia Schulz, a young dancer at the Sturm-Bühne in Berlin, dancing nude was much more than just part of a new culture of pleasure; it was an expression of a newly acquired freedom and, above all, an innovative art form.

A dancer in the Ziegfeld Follies, 1920s.

Schulz, for instance, wore full-body Expressionist masks onstages in Hamburg, after she left Berlin. The excitement that both women regularly caused with their performances sometimes caused their sensation-seeking audiences to forget that these were very much avant-garde artists sliding over the parquet floor before them.

When Josephine Baker came from Paris to Berlin with *La revue nègre* in 1926 and infected the German capital with Charleston fever, in Paris, the European center of American expatriates, they were already a step ahead. In the revues on the Champs-Élysées, the fashionable dance from overseas had already become a regular part of evening programs before Baker's arrival in 1925. It was booming in the dance bars of Montmartre and Montparnasse. The Jockey Club, the model for the eponymous club in Berlin and the meeting place for the Lost Generation and the bohemians on the boulevard de Montparnasse, overflowed every night. It was known for hiring the best jazz pianists in the city. The multitalented Kiki de Montparnasse began her career as a chanson singer there—and she would dance into the wee hours after her performances.

The starting point of the triumphant march of the Charleston through the metropolises of the world was, however, a jazz revue on Broadway. In the musical *Running Wild*, the pianist James P. Johnson played his pioneering composition "The Charleston" for the first time in 1923. It spread like wildfire and was in all the clubs and speakeasies of New York in no time. New York's flappers took the dance to the illegal bars, performed it in short skirts (it would not have been possible otherwise), and understood it as a form of protest against both Prohibition and an anachronistic image of women. The first "export attempts" occurred as early as 1924. Louise Brooks, then just a teenager and still a tiny star on Broadway, astonished the guests in the Café de Paris in London with her dancing. Half a year later, Josephine Baker helped the Charleston achieve its ultimate breakthrough in the Old World.

Visitors to one of the then-popular cabarets, ca. 1925.

Millions of . . . ragingly pleasure-seeking men and women lurch and reel away in the jazz delirium. The dance becomes a mania, an idée fixe, a cult. . . . It gets lively—or, rather, it gets absolutely chaotic.

—Klaus Mann

ANITA BERBER
1899–1928

*She was the most daring woman of her time.
She burned her brief life. The youth of today can
identify with her only all too well.*

—Karl Lagerfeld

On the evening of November 14, 1922, there was not a single empty seat in the Grand Hall of the Konzerthaus in Vienna. The audience came in droves to attend the premiere of a guest performance by a "scandalous dancer" who had managed to turn the world of the German stage upside down. Anita Berber, with her partner Sebastian Droste, exhibited the *Tänze des Lasters, des Grauens und der Ektase* (Dances of Vice, Horror, and Ecstasy). And, as usual when she performed, the audiences and critics were divided in their assessment afterward. "Some," the *Wiener Volks-Zeitung* wrote shortly thereafter, "praised the unique artistry of the dances; others were outraged that a woman dared and could dare to present herself entirely nude. And the number of those who saw the main sensation of the dance in that fact was

Anita Berber, 1920. Photograph by the internationally renowned Dora Kallmus, who also went by the name Madame d'Ora.

not small." Anita Berber did not care that she regularly called into action the guardians of bourgeois morality. She understood dance as the optimal expression of sensuality, which is conveyed most purely by a naked body. Regardless of whether her audience perceived her as an artist or as a naked revue girl, she had become the German sex symbol of the early 1920s.

As the daughter of a concert violinist and cabaret singer, she was in a sense born to music. At seventeen, she became a member of the ensemble of the respected ballet school of Rita Sacchetto, to which Valeska Gert and the future writer Dinah Nelken also belonged. Nelken was struck not only by Anita Berber's enormous charisma but also by the fact that the ballerina was only happy "when her followers did not merely applaud but loudly shouted 'Anita, Anita.'" Such thunderous applause was soon frequent. Her very first solo evening was so celebrated that the dance theaters of Berlin fought over her from then on.

Anita Berber's dances are ardor experienced. . . . [She] has incited a revolt in the brief time her performance lasts.

—Max Herrmann-Neisse

In 1920, nude dancing came into fashion in a big way. The performances of the Celly de Rheydt-Ballett, the very first nude ballet of the German Reich, on Kurfürstendamm, were *the* sensation and always sold out. Anita Berber signed up there and quickly became the troupe's main attraction. One year later, having since become famous, she was the first dancer to perform in the nude in Sankt Pauli—until it was officially prohibited, even in that notorious red-light district of Hamburg. Her success was great, and soon it was no longer limited to dance stages. Several film directors were paying attention: In *Der Falschspieler* (The Cheat) by Emil Justitz, Anita Berber acted alongside Hans Albers. Richard Oswald hired her for his horror classic *Unheimliche Geschichten* (Eerie Tales), among others. In Fritz Lang's masterpiece, *Dr. Mabuse, der Spieler* (Dr. Mabuse the Gambler), she was the double for the female lead, Aud Egede-Nissen, in all the dance scenes. The photographer Dora Kallmus, the first woman to study photography at the Graphische Lehr- und Versuchsanstalt in Vienna, who since 1907 had been running a studio in Vienna's first district under the name Madame d'Ora, discovered Anita Berber and took entire series of portraits and fashion shots of her. Her photographs appeared regularly in journals such as *Die Dame* and *Elegante Welt*. In Berlin, "the Berber," as she was soon known by everyone, became the cult figure and luminary of nightlife. The man she had married in 1919, the officer's son Eberhard von Nathusius, played hardly any role in her life any longer; in 1922, they separated by mutual agreement. She had a number of affairs with both men and women. In Berlin's lesbian scene—which at the time was not just tolerated but almost fashionable—she "debuted" at the side of her friend Susanne Wanowski, who ran the women's bar La Garçonne in Schöneberg. Both regularly appeared at the nightclub Die Pyramide, "greeted with a big hello," as Claire Waldoff recalled. "The stunning dancers Anita Berber and Celly de Rheydt and the beautiful Susi Wanowski and her crowd . . . It was the typical Berlin nightlife with its sin and its color." Sometimes in a tuxedo with derby and monocle,

sometimes in a décolleté evening gown with a monkey on her neckline, Anita Berber embodied the zeitgeist. "For a time, all of the chic women in Berlin imitated everything about her. Down to the monocle. They went à la Berber," wrote the dramaturge Siegfried Geyer in *Die Bühne*. "Anita Berber was already a legend," recalled Klaus Mann. "She had only been famous for two or three years but had already become a symbol. Spoiled bourgeois girls copied Berber; every better cocotte wanted to look as much like her as possible." In the Berlin of the early 1920s, she was the measure of all things and present at every ball in the city. But while she doubtless enjoyed her fame, dance was more important to her than publicity.

Her affair with the Hamburg dancer Sebastian Droste, who joined the Celly de Rheydt ensemble in 1920, marked the height of her career. Droste, whose legal name was Willy Knobloch, was multitalented and living proof of how close together genius and madness are. In addition to innovative dance choreographies, he produced Expressionist paintings and poems, was a confessed hedonist, and was addicted to drugs. With him Anita created the *Tänze des Lasters*: *Kokain* (Cocaine) and *Morphium* (Morphine), which premiered in Vienna in 1922. The renowned dance critic Joe Jencik, who was sitting in the audience at the time, wrote enthusiastically: "*Kokain* and *Morphium* represent in Anita Berber's work the most essential and most personal artistic creations, which at times border on a pathological study of a brilliant pantomime."

The dancer knew exactly what she was dancing about. Even before her time with Droste, Anita Berber was not averse to drugs of any kind—especially not cocaine. At the time, cocaine was *the* fashionable drug in Berlin, and its consumption was not by any means limited to circles of the demimonde. It is documented that she tested the effects of the white powder early on. But her consumption only became excessive during her affair with Droste. The use of drugs became a component of the artists' self-image. "I only know," she told the Hungarian newspaper *Pesti Napló* in 1927, "that no one ever

Anita Berber and Sebastian Droste
in *Morphine*, 1922.

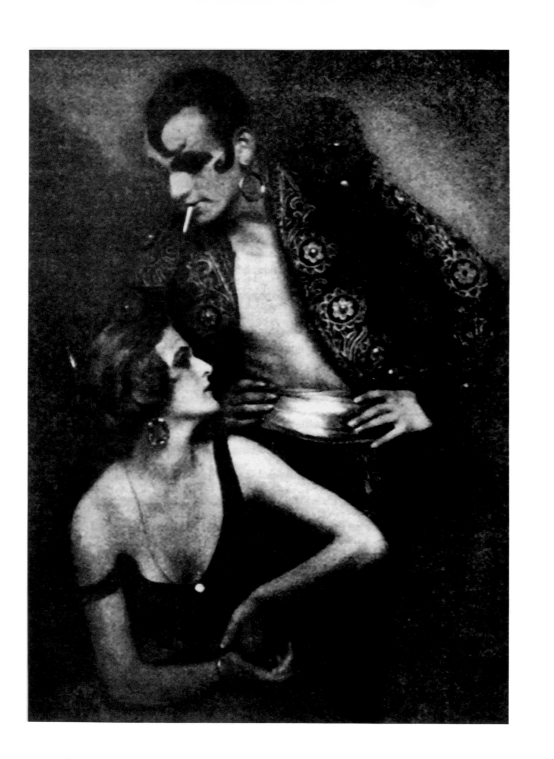

led as feverish, fast, and greedy a life as we did when we were dancing together." They danced together until 1923. Then Droste, who was known to the police for fraud, fled to New York with valuable pieces of his dance partner's jewelry in his luggage.

Droste's disappearance represented an opportunity for a new beginning. In 1924, Anita Berber married the young American dancer Henri Châtin-Hofmann and performed with him in a new program in numerous cabarets and variety theaters. They never received any lucrative film offers, however, as she was considered too unpredictable and unreliable. Her reputation was considerably damaged after her *amour fou* with Droste, nor did the press help matters. "All the people say I had gone crazy and was locked up as mad," she once wrote in an outraged letter to an editor, "yet I am lying very comfortably in the sanatorium . . . and merely recovering from mild peritonitis."

Anita Berber increasingly felt misunderstood. She wanted to be perceived as an artist, not as a magnet for scandal. But sometimes a scandal was unavoidable. When heckled during her performances—usually in the notorious nightclub Die Weisse Maus, where guests wore masks in order to remain anonymous—she sometimes got physical. "I was insistent," recalled the editor of the culture pages of the *Berliner Tageblatt*, Fred Hildenbrandt, who tried to calm her after one of her performances, "that this nude dancer was dancing a serious program . . . and demanded that an audience looking for an erotic amusement understand that." After she had struck a noisy customer over the head with a bottle of champagne, she was prohibited from performing there again. The Berlin singer Henny Walden, who frequented the Weisse Maus at the time, summed up the dancer's dilemma: "Anita Berber. The goddess undressed every night in a different dive for the sake of her art, and no one understands her."

Anita Berber literally danced until she dropped. During a tour with Châtin-Hofmann that had initially taken them through Athens, Cairo, and Alexandria, she collapsed on a stage in Damascus. The diagnosis was "galloping consumption," tuberculosis. The

"dancer of the inflation years," as she was called in numerous obituaries, died in November 1928 at the age of twenty-nine in Berlin-Kreuzberg. "Anita Berber belonged to those plantlike creatures," as Siegfried Geyer tried to explain to the readers of *Die Bühne* in his appreciation of her, "who would receive the tax collector while sitting naked in the bathtub and think nothing about visiting a lawyer and suddenly discovering at his office that they have nothing on under their overcoat because they completely forgot that it was necessary to dress for a visit. In such cases, Anita Berber did not say: 'I forgot to get dressed, sorry!' but only: 'Give me a cigarette; I left my snuff box behind.'"

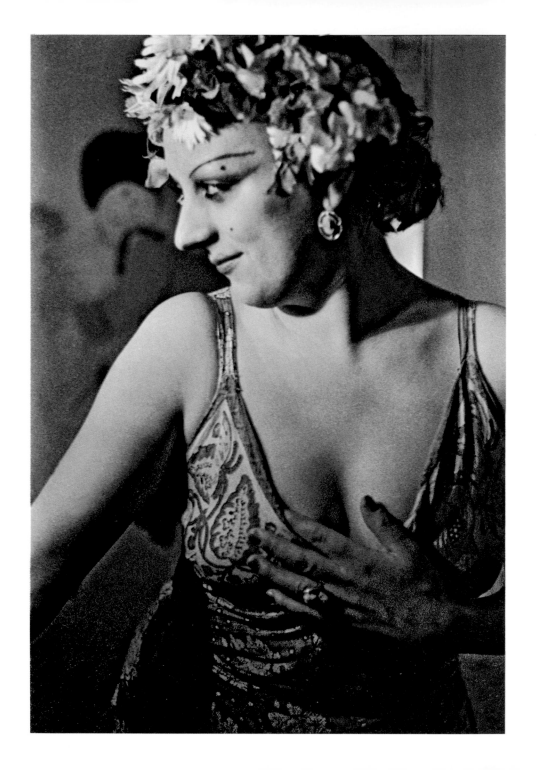

KIKI DE MONTPARNASSE
1901–1953

*She certainly dominated the era
of Montparnasse more than Queen Victoria
ever dominated the Victorian Era.*
—Ernest Hemingway

The news spread like wildfire in the quarter, and the line of those waiting in front of the Édouard Loewy bookstore on the boulevard Raspail kept growing. On the evening of October 29, 1929, Kiki, the "Queen of Montparnasse," was holding a book signing—and everyone who purchased her memoir, *Souvenirs*, hot off the press, for thirty francs would also receive a kiss. According to the *Paris Tribune*, the residents of the quarter—that is, the men—dropped what they were doing and rushed over. The promotion turned the book into a best seller overnight. The American journalist Samuel Putnam was hired as the translator of the English edition, to be published the following year with a foreword by Ernest Hemingway. Putnam hesitated at first. The situation was a bit tricky, he felt: "The problem is not to translate Kiki's text but to translate Kiki."

Kiki de Montparnasse, 1925.

In the Paris of the 1920s, Kiki, née Alice Ernestine Prin, was a true star and known far beyond the borders of France. She sat for Man Ray, Moïse Kisling, Tsuguharu Foujita, and Chaim Soutine as a life model. She was herself a painter and worked as a nightclub singer and actress. The writer Dan Franck sees her as the "first important figure of this post-war Montparnasse, whose sulphurous reputation she would help to build—known as she was, as far afield as America, for her antics and high spirits." The multitalented diva of Parisian bohemia knew how to draw eyes and attention to herself. In addition to her deep, melodic voice, she employed a markedly lascivious attitude. "Her *maquillage* was a work of art in itself," wrote the Canadian poet and eyewitness John Glassco, "her eyebrows were completely shaved and replaced by delicate curling lines shaped like the accent on a Spanish 'n,' her eyelashes were tipped with at least a teaspoonful of mascara, and her mouth, painted a deep scarlet that emphasized the sly erotic humour of its contours, blazed against the plaster-white of her cheeks on which a single beauty spot was placed, with consummate art, just under one eye."

The beginning of her career was bumpy, however. Born out of wedlock, she grew up under modest circumstances with her grandmother in Châtillon-sur-Seine, Burgundy, before following her mother to Paris in 1915. Kiki lost her job as a baker's assistant after a physical confrontation with the baker's wife, who had called the girl a whore because of her weakness for makeup. At fifteen, Kiki ended up in an artist's studio for the first time, to pose as a nude model for a pittance. Two years later, she met the Polish painter Maurice Mendjisky, to whom she owed the nickname "Kiki"—an affectionate form of the name Aliki, the Greek version of Alice. Mendjisky produced the first famous portrait of her. Through him she met Moïse Kisling at the Café Parnasse on the boulevard Montparnasse. Kisling immediately engaged her as a model for three months. For Kiki, this was a breakthrough; the several pinup photographs that had been taken of her had not been lucrative. The job with Kisling was followed by modeling

Kiki de Montparnasse, 1920.
Photograph by Gaston Paris.

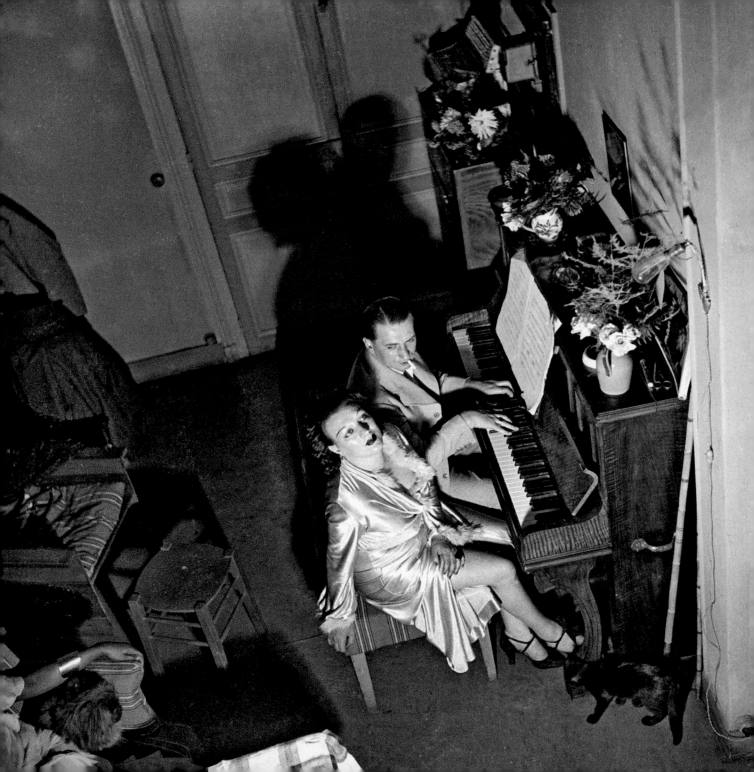

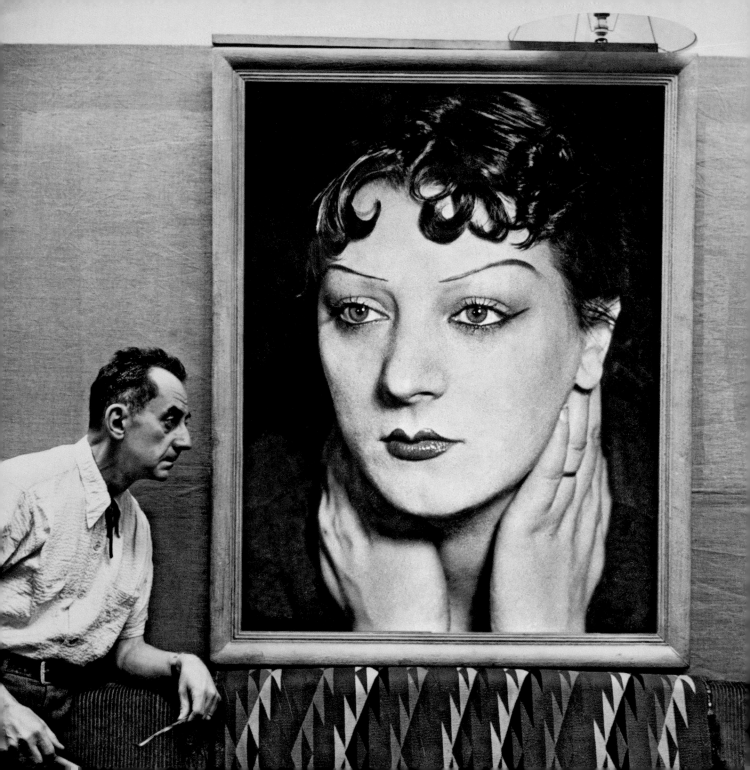

sessions for artists such as Per Krohg, Kees van Dongen, and André Derain. Her first meeting with Tsuguharu Foujita in his studio on the rue Delambre: Kiki reacted to the shyness of the modest Japanese man by taking the pencil from his hand and drawing a portrait of him—that broke the ice, and Foujita painted a large nude of Kiki that was discussed for days by the press and was ultimately sold for an unexpectedly high price.

Montparnasse is a village that is as round as a circus. You get into it you don't know just how, but getting out again is not so easy.

—Kiki de Montparnasse

The most famous image of Kiki, however, is by Man Ray. They met in late 1922, and in the years that followed, Kiki became the American's favorite model and lover. He produced numerous photographs of her, including *Le violon d'Ingres*, one of the most frequently published of all of Man Ray's photographs—a suggestive portrait collage in which Kiki's exposed back looks to the viewer like a violin. Through Man Ray and his contacts, Kiki also conquered the cinemas of the city. She performed in his Surrealist film *Emak-Bakia* as well as in the experimental works of Fernand Léger and Pierre Prévert.

Kiki's presence was not limited to the cinemas of Paris and the studios of its artists. In late 1923, the Jockey Club opened on the boulevard du Montparnasse, and it quickly became the meeting place of all the creative people of the quarter. The Jock-

Man Ray in the 1950s, in front of one of his 1920s photographs of Kiki de Montparnasse.

ey's dance floor was always full of people—so many that the painter Jean Oberlé "saw a pretty young girl dancing completely nude, and no one noticed it." Kiki was a frequent guest from the very beginning, regularly appearing as an interpreter of frivolous chansons, dancing the cancan and later the Charleston. She soon became the main attraction of the club. The receipts, which were collected by a hat circling through the guests, were divided among all of the performers.

Her eyebrows were completely shaved and replaced by delicate curling lines . . . , her eyelashes were tipped with at least a teaspoonful of mascara, and her mouth, painted a deep scarlet that emphasized the sly erotic humour of its contours, blazed against the plaster-white of her cheeks on which a single beauty spot was placed, with consummate art, just under one eye.

—John Glassco

Kiki was also a welcome guest at the parties of high society and of bohemian artists. Sooner or later she would become the center of any gathering. She attended the openings of Joan Miró, Kees van Dongen, and others wearing very low-cut dresses she

had designed herself, which inspired many of the fashion personalities present—Paul Poiret, Jeanne Lanvin, and Coco Chanel. Sometimes she even brought a small pet along: a mouse she carried around in a specially made basket the size of a handbag. "Life," she said to Djuna Barnes, "is, *au fond*, so limited, so robbed of new sins, so *diabolique*, that one must have a mouse, a small white mouse, *n'est-ce pas*? To run about between cocktails and *thé*."

In 1927, the Galerie au sacre du printemps on the rue du Cherche-Midi exhibited her paintings, and everyone who was anyone in artistic circles came. "It was," the *Paris Tribune* wrote, "so far as we know, the most successful vernissage of the year." At that time Kiki's popularity was already heading for its peak, which it reached with the publication of her memoirs.

The end of the Roaring Twenties was also the end of Kiki's era. Like many artists, she was hit hard by the Great Depression. Over the years she continued to appear in cabarets and nightclubs, but her star fell, and almost nothing is known about her later activities. Kiki was as a phenomenon of the 1920s. According to her biographers Billy Klüver and Julie Martin, she was one of the very first absolutely independent women. She took what she wanted, and when she didn't get it, things could get unpleasant. The prominent American art dealer Julian Levy got a taste of that once: when he ignored her unambiguous advances, Kiki mocked him by saying, "Vous n'êtes pas un homme, mais un hommelette."

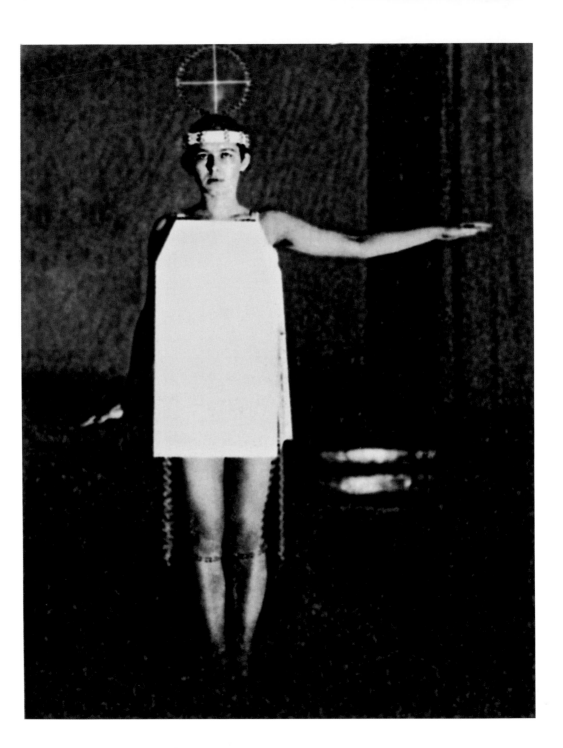

LAVINIA SCHULZ
1896–1924

Since I was seventeen, I have felt my life is just a purgatory.
When will I get through it?
—Lavinia Schulz

P arties in Hamburg?—"Certainly, they exist," the journalist and critic Hans W. Fischer assured his readers in the *Hamburger Kulturbilderbogen*, countering the common cliché that no wild parties took place in the city of the sober Hanseatics in the early 1920s. Fischer knew whereof he wrote—along with other artists and intellectuals of Hamburg's avant-garde, the head of the culture pages of the *Neue Hamburger Zeitung* was on the planning committee of an event that, in the words of the writer Hans Leip, burst annually "like a shockwave into the Hanseatic black-bread complacency": the Hamburger Künstlerfeste (Hamburg Artists' Festival) in the Curiohaus on Rothenbaumchaussee. The festival was famous throughout Germany, and had themes such as "The Kettledrum of the Idols," "The Heavenly Top," or "Cubicuria: The Strange City." It was a spectacle: through halls lavishly decorated and imaginatively lit

Lavinia Schulz in a performance by Lothar
Schreyer at the Kampfbühne, 1919.

by the Hamburg Secessionists, swarms of ecstatic, wildly costumed people made their way toward the stage, flanked by meters-high sculptures. The sisters Gertrud and Ursula Falke danced in Dada performances; the dancers Mary Wigman and Valeska Gert appeared, as did Elsbeth Baack, who sometimes removed all her veils. The high point of the festival, however, was Lavinia Schulz, who whirled across the parquet floor with her partner, Walter Holdt, covered in Futurist masks of burlap, plywood, wire, and wool.

Dance, sound design, and mask. That is a triad, a tri-prayer. The solution of this task will certainly be of great significance for the German culture of language, dance, and theater. Where are the people who are farsighted enough to support these two?!

—Karl Lorenz on the dancers
Lavinia Schulz and Walter Holdt

Lavinia Schulz's career began in Berlin, where the dramaturge Lothar Schreyer discovered her at Herwarth Walden's Sturm-Bühne (Storm Stage). Schreyer initially employed his "first female student" as a costume designer, but he soon recognized her potential as a dancer and encouraged her in the ambitious technique of *Klangsprechen* (sound speaking). In 1918, she debuted in the title role of August Stramm's Dadaist play *Sancta Susanna*, which was performed only once, directed by Schreyer, and trig-

gered an enormous scandal: "Lavinia Schulz," Schreyer recalled, "a brilliant person of wild passion who, restrained only by the discipline of art, played—nude—Sancta Susanna, as the audience remained breathless—perhaps horrified—and at the end of the play offered the drama of the battle of two worlds with frenetic applause and wild protests." The performance ended with physical conflicts and the intervention of the police. The play flopped in the press, and the dramaturge and his theatrical artist went to Hamburg, where he founded the Kampfbühne (Battle Stage) at the Kunstgewerbeschule am Lerchenfeld. There Lavinia Schulz met the dancer Walter Holdt, who was two years her junior. It would turn out to be a fateful encounter. Their stormy relationship repeatedly led to tumults during rehearsals and once even went so far that the dancer dragged her partner by the hair through the dance hall. "It is a hard test of my nerves, but artistically we need Schulz," Schreyer complained to Herwarth Walden. But, because the *Klangsprechen* that Schreyer favored began to seem lifeless to her, her engagement at the Kampfbühne ended early.

Holdt's activity at the Kampfbühne also ended with Lavinia Schulz's departure, and in a basement apartment near the Hamburger Kammerspiele, the impulsive couple turned completely to another form of expression from 1920 onward: masked dance. Lavinia Schulz was the creative head of the duo. She made their whole-body costumes herself with the simplest materials imaginable. In addition to burlap and wood, she employed plaster, cardboard, metal, and even industrial waste. The resulting masks looked like hybrids of robots and insects and were, as the journalist Erich Lüth put it in the *Hamburger Anzeiger*, "not worn, not a costume, but rather the dancing body proper, to which the living body merely lent its energies." Skirnir, Springvieh (Jumping Beast), and Technik (Technology) were the names of some of her characters, two of the most famous of which—"Toboggan" and "Sie" (She)—recall in their details the powerful colors of Fernand Léger and Sonia Delaunay.

The choreography and rehearsals were done in the dark basement apartment, which served both as workshop and bedroom, and into which Hans Heinz Stuckenschmidt, who wrote the music for their performances, also moved for a time. Lovis H. Lorenz, who later cofounded the newspaper *Die Zeit*, recalled the opening of a sensational performance by the couple at the Hamburger Kammerspiele: "Two bangs on a gong produced silence; the orchestra began. In the middle of the stage, with limbs spread, a figure stood, motionless at first. Head, torso, and limbs hidden in rows of colorful cubes. A bizarre structure of colorful cardboard boxes. Only the glimmer of the spotlight betrayed that a person was breathing hard beneath them." The press occasionally praised the innovative potential of their dances, which led, among other things, to performances in the popular revues of the Cabaret Die Jungfrau (The Virgin) on the Jungfernstieg.

Lavinia Schulz understood her masked dancing as the "pure art of the spirit" and on principle regarded performance in exchange for a fee as betrayal. The small sums that the couple collected from admission fees were completely invested in the production of masks. That level of idealism necessarily led to financial difficulties. To avoid the worst, Holdt played in a jazz band with Stuckenschmidt in the Alkazar nightclub on the Reeperbahn, while his wife—they had married in secret, against the wishes of their parents—worked alone on the masks. They did not heat their basement apartment, lived on vegetable soup and tea, and slept in hammocks under horse blankets. Things grew even more difficult when Lavinia Schulz was unable to work in 1923 because she was pregnant. The birth of their son clearly had a detrimental effect on the young father's discipline: while the newborn demanded the complete energy of his already exhausted mother, Holdt spend nights in the city's trendy bars. A marital crisis was thus inevitable, and it ended with a great bang. "This morning," the *Hamburger Fremdenblatt* wrote on June 18, 1924, "the twenty-eight-year-old wife Lavinia Holdt shot her twenty-five-year-old husband, the artiste Walter Holdt. Shortly after 7 a.m., Mrs. Holdt entered an

The masked dance *Technology* by Lavinia Schulz, 1924. Photograph by Minya Diez-Dührkoop.

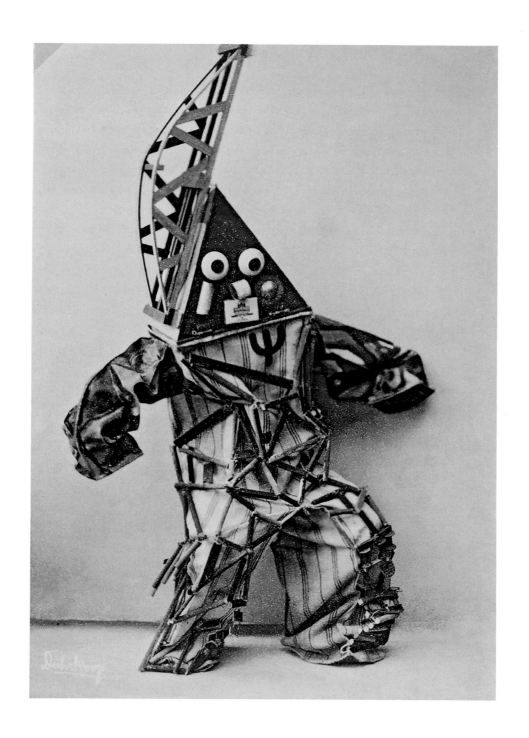

apartment on the raised ground floor and declared that she had shot her husband. Then Mrs. Holdt returned to her apartment on the ground floor and immediately thereafter a shot was heard. The police who were called found the woman in the antechamber of the bedroom with an injury from a shot to the head, still alive on the floor, while the man was dead in the bed."

The son was unharmed, but Lavinia Schulz died a few hours later at the hospital. Her unique dance masks have become famous, after decades in hibernation in nondescript shipping crates. They are now in the collection of the Museum für Kunst und Gewerbe in Hamburg and traveled to Paris in late 2011 for the exhibition *Danser sa vie* at the Centre Pompidou.

Some among them [the viewers] will have been astonished that we present our artistic offerings or events without reimbursement. The spiritual cannot be purchased with money. Spirit and money are two hostile poles, and if one sells the spiritual for money, one has sold the spirit to the money and lost the spirit.

—Lavinia Schulz

The dance couple *Toboggan* (Lavinia Schulz and Walter Holdt), ca. 1924.

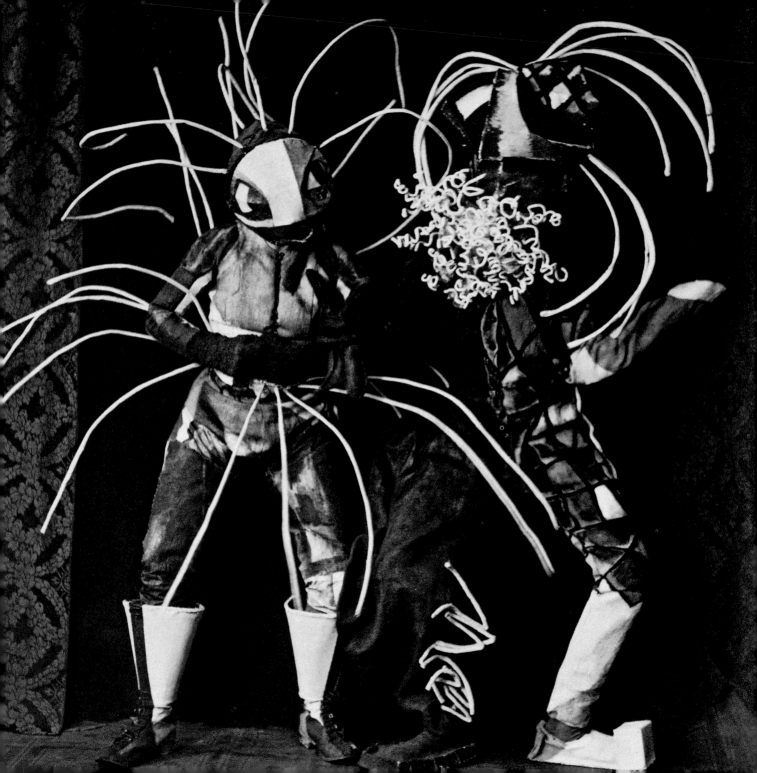

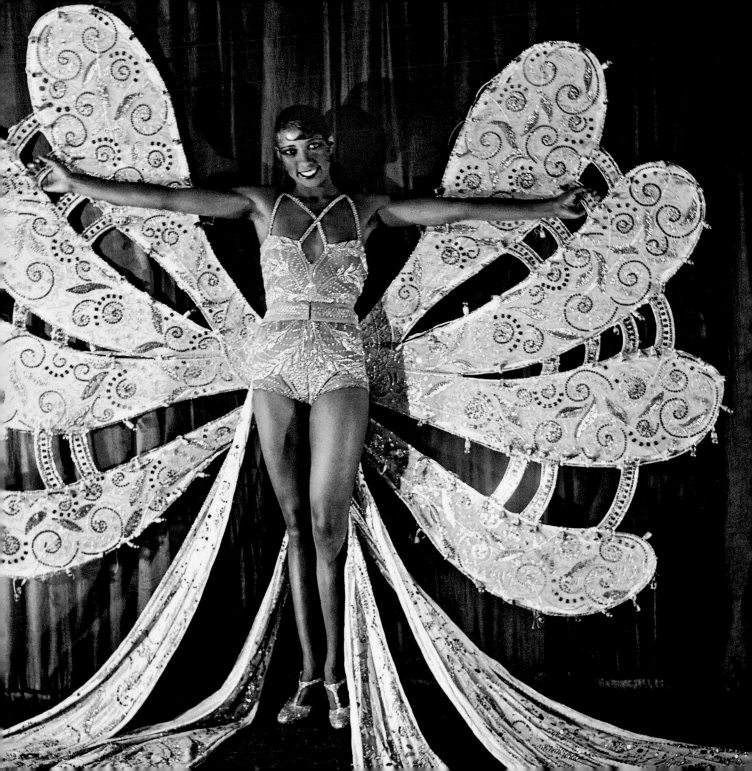

JOSEPHINE BAKER
1906–1975

I wasn't really naked. I simply didn't
have any clothes on.
—Josephine Baker

Josephine Baker would never forget the first stage rehearsal for *La revue nègre* at the Théâtre des Champs-Élysées. It was so hot on that day in September 1925 that both the still photography and the warm-up dances were moved to the roof of the theater. The nineteen-year-old black dancer from America attracted countless curious gazes from the neighborhood as she jumped about to the rhythms of loud jazz music, dressed in a close-fitting leotard and making wild faces. In the auditorium where the rehearsal continued, Josephine Baker danced her Charleston on European soil for the first time and swept all those present into the dance with her: "The theater is dark, the stage is lit," she described the scene. "There are twenty people in the first row. Hello! Charleston. The stagehands watch, the two firemen are amazed. They are not used to receiving trombone blows in the stomach. At the end, behind the scenery, the

Josephine Baker on the stage of the Casino
de Paris in the show *Paris qui remue*, 1930.

younger ones try to imitate, they would like to dance the Charleston; they shake flannel legs, they kick their feet in the air like cows, they also kick their neighbors. The Charleston already possesses them. 'Yes, sir, that's my baby.'"

Josephine Baker certainly performed pioneering work for her "baby," the Charleston, and all of Paris was on its feet after her performances in *La revue nègre*. People crowded the dance floors of clubs and trendy bars to follow this chic new craze, which would be-

Poster depicting Josephine Baker and her leopard, Chiquita.

come the trademark of a whole generation, and not just in America. In Paris, the young jazz dancer from Saint Louis became world famous, but this out-of-wedlock daughter of a black laundrywoman and a white man had already enjoyed early success in New York. In 1921, at the age of fifteen, she joined the ensemble of the revue *Shuffle Along*—the show that brought black dancers and musicians to Broadway and in the process revolutionized American variety theater. At first, she was hired to work in the cloakroom. When one of the dancers was injured, she jumped in—and literally danced the others right up against the wall. Making faces, she slid across the parquet floor and repeatedly broke up the choreography. In contrast to her fellow dancers, from whom she stole the show, the audience was extremely taken by her performance. She remained in *Shuffle Along* for two years, until it closed, and the composers of

the revue, Eubie Blake and Noble Sissle, made her a new offer: a lead in the new Broadway show *The Chocolate Dandies* for a remarkable 125 dollars a week.

Although the new revue was only moderately successful, for Josephine Baker it represented a breakthrough in New York. The press savaged the show but excepted "the comic little chorus girl whose very gaze was syncopation and whose merest movement was a blues," as one charmed reviewer wrote. In the meantime, she had moved to Harlem, which, along with Greenwich Village, was the musicians' district of New York. Its legendary jazz clubs—including the Cotton Club, where Duke Ellington played— attracted the smart set and the bohemians of the city, as did the speakeasies along Lenox Avenue. In 1925, Josephine Baker was dancing a solo at the popular Plantation Club on Broadway, in the same show that featured the singer Ethel Waters, the club's star and later one of the great icons of jazz. A regular visitor at the Plantation Club was the Parisian theatrical agent Caroline Dudley, who had traveled to New York to recruit musicians and dancers for the new *Revue nègre* in Paris. After Ethel Waters gave her the brush-off, Dudley turned to Josephine Baker and was successful—above all because the dancer was tired of the rigorously practiced segregation in her homeland. Over four years, Baker had come to realize that discrimination based on skin color was part of daily life even in liberal New York. Because she was black, she was prohibited from entering certain clubs and businesses in central Manhattan or from choosing a seat freely in the theater. "I knew the Eiffel Tower from a postcard," she explained her choice later. "Naturally it has no symbolic meaning like the Statue of Liberty. But what use is the Statue of Liberty when there is no freedom, when I cannot enter some bars." She quickly made up her mind to accept the offer of the agent from Paris—though not without first negotiating a considerably higher fee.

Josephine Baker was one of the many women who left New York to seek their future in Paris. Most found it, as the biographies of Gertrude Stein, Janet Flanner, Elsa

Schiaparelli, and others demonstrate. Unlike these women, however, the revue girl from Broadway had few contacts in the metropolis on the Seine to ease her transition into expatriate life; one exception was the black singer Ada Smith, who called herself Bricktop and who had performed in numerous nightclubs in Harlem with varying degrees of success before moving to Paris in 1924. In a very short time, Smith became the star of the cabaret-café Le Grand Duc in Montmartre, one of the favorite meeting points of the avant-garde, especially the American exiles around Hemingway, Cole Porter, and Zelda and Scott Fitzgerald. Smith, who was ten years Baker's senior, took her under her wing. With Bricktop, Baker attended the Charleston parties that Cole Porter held regularly in his villa on the rue Monsieur. There she taught the guests the new dance and made contacts in the Parisian music and art scene. For the sensational poster by the graphic artist Paul Colin advertising the *La revue nègre*, which was displayed all over the city, she posed nude for the first time; Colin became one of her closest friends and for a time her lover as well. Onstage, too, she performed nearly nude. At evening receptions and banquets, by contrast, she wore designs by the couturier Paul Poiret. Josephine Baker began to get a toehold in Paris; nevertheless, her time on the Seine nearly became an intermezzo, for Berliners, too, passionately tried to entice the exalted dancer to their city.

Since the early 1920s, Berlin had been, along with Paris, a metropolis of dance; the city's theaters and dance halls were booming. The guest performance of *La revue nègre* at the Nelson-Theater on Kurfürstendamm in 1926 thrilled audiences. Every show sold out, and the *Berliner Illustrierte Zeitung* celebrated Josephine Baker as an icon of Expressionist dance. The city's bohemian night owls could even admire breathtaking performances after the show, as an entry in Count Harry Kessler's diary about an evening at the home of the dandy Karl Gustav Vollmoeller demonstrates: "So I drove to Vollmoeller in his harem on Pariser Platz," he wrote, "and there I found . . . among a half dozen

Josephine Baker in her dressing room
at the Casino de Paris, 1930.

naked girls, Miss Baker as well, also completely nude apart from a pink gauze apron, and little Lanshoff . . . as a youth in a tuxedo. Baker danced with the most extreme art of the grotesque and stylistic purity. . . . The naked girls lay or pranced among the four or five men in tuxedos, and little Lanshoff, who truly looks like a picture-pretty young man, danced modern jazz dances to the gramophone with Baker." Kessler was so enthusiastic about Josephine Baker's dance with Vollmoeller's lover, the actress Ruth Landshoff, that he soon offered the star of *La revue nègre* a starring role in a dance pantomime. Max Reinhardt, the manager of the renowned Deutsches Theater and another guest at Vollmoeller's, wanted to engage her for his ensemble and said, "With such control of the body, such pantomime, I believe I could portray emotion as it has never been portrayed." The dancer was nearly persuaded by the luminaries of the Berlin theater scene to remain there, but the fact that she had already signed the contract for a new revue ultimately kept her from doing so.

Many women are only concerned about their reputation; but the others will be happy.

—Josephine Baker

At the Folies Bergère, starting in 1926, Josephine Baker performed her famous nude dances in a banana skirt. This variety theater on the rue Richer was an institution in Paris. The shows were rehearsed for months; they had hundreds of workers and more than a thousand costumes. Baker had risen to be the highest-paid dancer in the city and the biggest star of the revue. From the rue Fromentin in Montmartre, she moved first to the Parc Monceau and later into a large apartment on the chic avenue Pierre-1er-de-

Serbie. The young author Georges Simenon, with whom she had an affair, worked for a time as her secretary and manager—a task soon thereafter taken over by the Sicilian playboy Pepito Abatino, whom Josephine Baker married in June 1927. She opened the nightclub Chez Josephine in Montmartre, where she would dance the night away after her revue shows. For the popular record label Odéon, she recorded several jazz songs. Paul Poiret continued to dress her, and photos of her from all of the city's magazines hung in the cloakroom of her nightclub. Paris showered her with applause, she recalled in her memoirs, which were published in 1927. Just how much Josephine Baker had won the heart of the city would become evident after the scandals arising from her tour of Europe in 1928. In Vienna and Budapest, her shows triggered protests—a considerable number of which had racist motives—for their violation of "public decency." In Prague, she had to flee an angry mob and escaped on the roof of her limousine; in Munich and other cities, her performances were banned from the start. These experiences marked her and later contributed to her passionate advocacy of tolerance and civil rights. Back in Paris, she performed as "Vénus noire," the female lead of a revue in the glamorous Casino de Paris in 1930. Henri Varna, the show's producer, gave his star a leopard that became her constant companion and brought additional publicity. When Baker strolled through the streets with Chiquita, as the big cat was called, the people cheered. Parisians liked such crazy ideas and appreciated Josephine Baker very much—and the feeling was mutual: "I understood Paris immediately and love it passionately," she wrote in 1927. "And I hope it loves me. Paris is dance, and I am a dancer!"

ADVENTURE & SPORTS

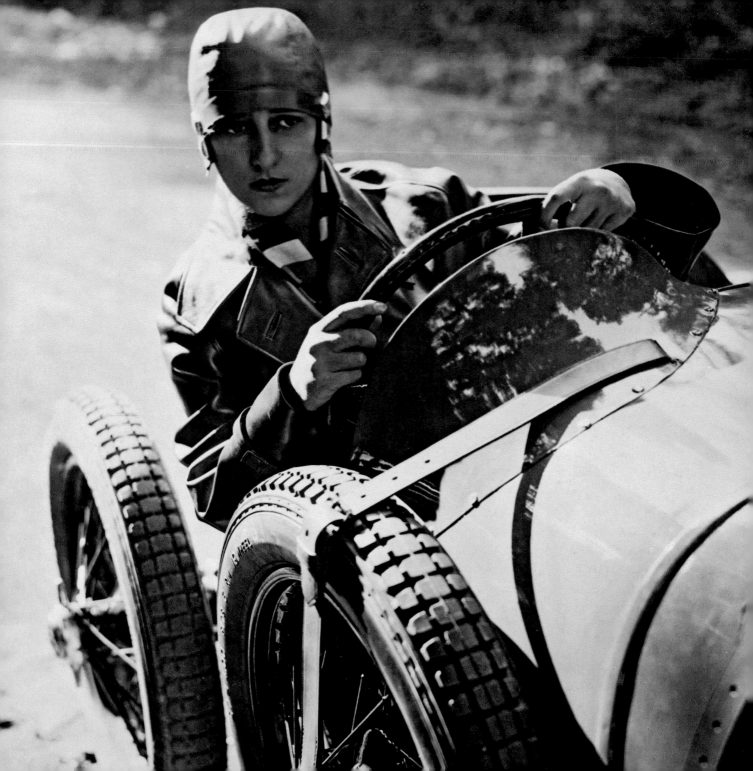

An article published in the *New York Times* in the early 1930s confirmed how the ideal image of the contemporary woman had changed over the course of the previous decade, in America as well as in Europe. "Any description of the ideal modern girl," it stated, "invariably specifies that she must be good at outdoor sports. A long stride, a strong arm, sunburned hair, a tanned complexion have come to be regarded as part of the picture of American beauty. . . . Today a group picture of women swimmers, golfers, tennis players, or fliers generally shows more than its average quota of good looks." Although by no means all female athletes of the 1920s were top models, as the article implies, they were types with whom women could identify. Sports had become a defining element of social life; athletic women became models and conquered magazine covers just as much as the stars of films and revues did. Women athletes such as the American Gertrude Ederle, who was the first woman to swim across the English Channel in 1926, or the multiple Wimbledon champion Suzanne Lenglen, were illustrated in *Vogue*, *Elegante Welt*, and *Vanity Fair*—as was the motorcycle rider Hanni Köhler, the only woman in the men's rankings, who was successful at the AVUS racetrack in Berlin, or the pilot Amelia Earhart. Occasionally, they even became sex symbols, like the tennis player Helen Wills, with whom, one newspaper wrote, practically every man in America had fallen in love.

Fashion designers ensured that the nimble, athletic type of woman had a suitable outward appearance. For the woman on skis, the woman playing tennis, and the woman swimming, Elsa Schiaparelli, Jean Patou, and others came up with creations that were visually pioneering and also allowed the freedom of movement necessary for these new pursuits. The most significant image of the Roaring Twenties, however, was the fashion-conscious woman behind the wheel. For the female sex, the automobile symbolized independence, mobility, and freedom. The automobile industry soon had women in its sights—no longer just to appear in advertisements but as customers. Automobile clubs

Woman driving a race car, 1928.
Photograph by André Kertész.

for women were founded, as were competitions, such as the highly popular AVUS races for women in Berlin. Women competed against men, too, and Clärenore Stinnes regularly left her male competitors far behind.

Never do things others can do and will do if there are things others cannot do or will not do.

—Amelia Earhart

In addition to the distinguished elegance with which the female sports stars of the 1920s represented their disciplines, their pioneering spirit and daredevilry also stood out. The challenge of athletics, the desire for maximum achievement, and, in the case of women in motor sports, the rush of speed and enthusiasm for technology motivated women to break with convention and imitate their idols. For example, the race-car driver Erika Mann followed in the footsteps of Clärenore Stinnes and drove down the Kurfürstendamm—wearing a chic leather outfit—as the winner of the 10,000-kilometer European Rally in 1931. A year later, Ella Maillart, who was also a talented skier and was even on the Swiss national team, caused a sensation when she and Annemarie Schwarzenbach drove a Ford convertible from Geneva to Kabul. "Adventure is worthwhile in itself," Amelia Earhart wrote, addressing the many women who would climb into planes after her or into cars after Clärenore Stinnes in order to traverse unprecedented distances and explore foreign countries. The daredevils Earhart and Stinnes were not just having fun; they also had a vision. They showed that the world could be interconnected and brought within the reach of everyone—especially women.

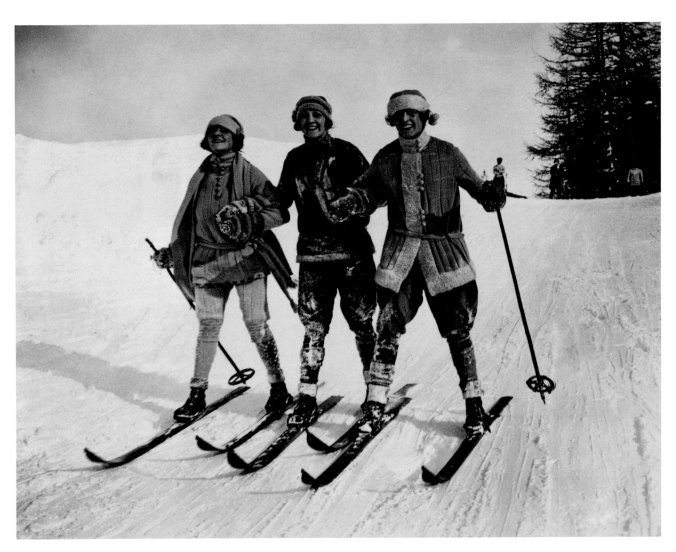

Three skiers on New Year's Day, 1924.

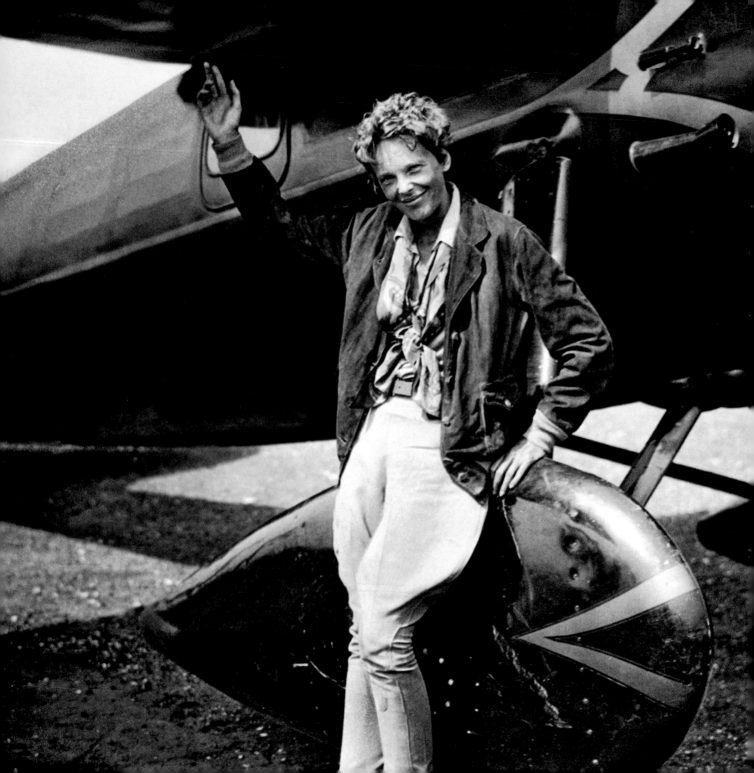

AMELIA EARHART
1897–1937

*I still didn't think of my flying as a means
to anything but having fun.*
—Amelia Earhart

The two-seat Kinner Airster biplane, that changed hands in Los Angeles in mid-1921 for $2,000 and was baptized "Canary," looked rather rickety, but for Amelia Earhart, its new owner, it was love at first sight. Not even the reservations of Neta Snook, her flight instructor, could change that. Although she had only taken a few lessons, the twenty-four-year-old novice pilot could hardly wait to take off in the bright yellow bird. Snook quickly determined, however, that the airplane was not easy to fly, even for trained pilots. Only later, after a number of flying lessons together, and still with mixed feelings, did she let her student pilot the Canary. As it turned out, her skepticism was justified. During one flight, one of the cylinders suddenly stopped firing, and they had to make an emergency landing. The plane struck the tops of several trees before they touched down, breaking the landing gear and propeller.

Amelia Earhart in front of her airplane, 1932.

Shocked, Snook climbed out of the plane and looked around for her student. Nothing had happened to Amelia Earhart; she was calmly powdering her nose because she wanted to look good, she said, if reporters were about to show up looking for a sensation.

Even as a young pilot in training, Amelia Earhart was conscious of fashion and style, and wanted to make an appearance that would attract publicity. The eyes of mechanics and pilots always followed the tall, attractive woman in riding pants and boots, leather jacket, silk scarf, aviator cap, and goggles as she swung into the cockpit. She was the first woman to become a legendary pilot—not least because of her disappearance over the Pacific during an attempted circumnavigation of the globe in 1937—but she also had a career as a fashion and media star.

At the beginning of her career, her appearance and outfit were not yet as important as her abilities at the controls. It was primarily due to the "recklessness" of her father, Edwin Earhart, that the girl from Kansas ended up being the first woman—and only the second person—to fly across the Atlantic nonstop. In late 1920, the attorney, who working out of their home in Los Angeles, gave his daughter ten dollars so she could take a ride in the plane of the popular stunt pilot Frank Hawks at an air show. "By the time I had gotten two or three hundred feet off the ground," said Amelia Earhart, "I knew I had to fly." She broke off her medical studies and began taking flying lessons just a few days later—an expensive venture; she worked twenty-eight different jobs within a year to pay for her flight training. It paid off: in December 1921, she received her license from the National Aeronautic Association, and a year and a half later she was admitted to the Fédération Aéronautique Internationale.

Although she had made her passion her profession, it was at best a second-rate way to earn a living. Amelia Earhart was much less motivated by the fees earned at air shows than by the challenge of the sport. Already in 1922, she set a record, as the first woman

to reach an altitude of 14,000 feet, and doubtless other great achievements would have followed if family problems had not put her career on hold. After her father lost the family's modest assets in speculative investments and also failed to get his alcohol problem under control, Amelia's mother, Amy, filed for divorce. With a heavy heart, Amelia Earhart then sold the Canary and traveled with her mother in a bright yellow Kissel sports car from Los Angeles to her sister Muriel's home in Boston. Amelia took a job there as a social worker. Her striking automobile quickly earned her local fame: "The fact," she wrote later in her autobiography, *The Fun of It*, "that my roadster was a cheerful canary color may have caused some of the excitement. It had been modest enough in California, but was a little outspoken for Boston, I found."

She helped the cause of women by giving them
a feeling there was nothing they could not do.

—Eleanor Roosevelt

An ambitious project by Amy Phipps Guest, who was as wealthy as she was enthusiastic about aviation, was what ultimately allowed Amelia Earhart to continue her career as pilot after an interruption of several years. Precisely one year after Lindbergh's pioneering act, Guest was preparing the first transatlantic flight by a woman, by an "American girl," as passenger. She had already purchased an airplane and entrusted the project of marketing to the publisher George Palmer Putnam. He imagined a candidate who was not only knowledgeable about the field but also appealing to the media and in a position to document the adventure in a book. Putnam, who had already had success

publishing Lindbergh's report *We* in late 1927, asked Amelia Earhart if she was interested. He need not have asked. On June 17, 1928, she took off from Newfoundland on board a Fokker with the pilot Wilmer Stultz and a mechanic and landed on the Welsh coast "20 hrs. 40 min." later, the title of her book published shortly thereafter by Putnam's publishing house.

The publicity that followed was enormous, and intelligently directed by Putnam. In London and New York, there were large parades and receptions. The press focused entirely on Amelia Earhart: "She looks more like Lindbergh than Lindbergh himself," the *New York Times* had written before the flight, alluding to the superficial resemblance between the two. The media immediately starting calling her "Lady Lindy." Putnam officially became her manager and cleverly marketed his protégée. Amelia Earhart promoted cigarettes and chewing gum and wrote columns for *Cosmopolitan*. The photographer Edward Steichen took pictures of her for *Vanity Fair* and *Vogue*. And she was elected president of the Ninety-Nines, an organization of female pilots. Despite her many PR obligations, aviation did not get short shrift: later in 1928, she flew across the United States, making many stops and setting new records for speed and altitude. Although her success was overwhelming, she was still bothered by the feeling that she had only been a passenger on the Atlantic crossing.

In early 1932, Amelia Earhart told Putnam, whom she had married after his sixth proposal, of her plan to fly to Europe again, this time as pilot at the controls, and solo. Packing two scarves, a toothbrush, tomato juice, and sandwiches, she took off from Harbour Grace in Newfoundland in a stop sign–red Lockheed Vega on May 20, 1932, five years to the day after Lindbergh's flight. Both her altimeter and her speedometer failed en route, but Earhart remained calm and landed on the Northern Irish coast just fifteen hours later. The triumphant tour that followed took her to European metrop-

olises by way of New York and the White House. Once again, the amount of press was gigantic; and, just as four years earlier, she had a dry response for reporters who asked what drove a woman of all people to such splendid achievements: "There is no fundamental difference between men and women that would prevent women having the same pleasure out of flying as men have."

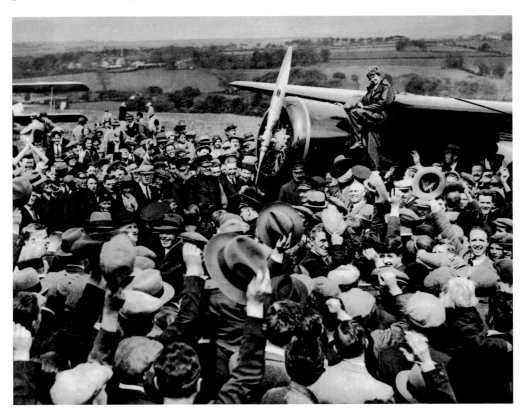

Amelia Earhart is surrounded by the curious in the Northern Irish town of Londonderry after her second Atlantic crossing, 1932.

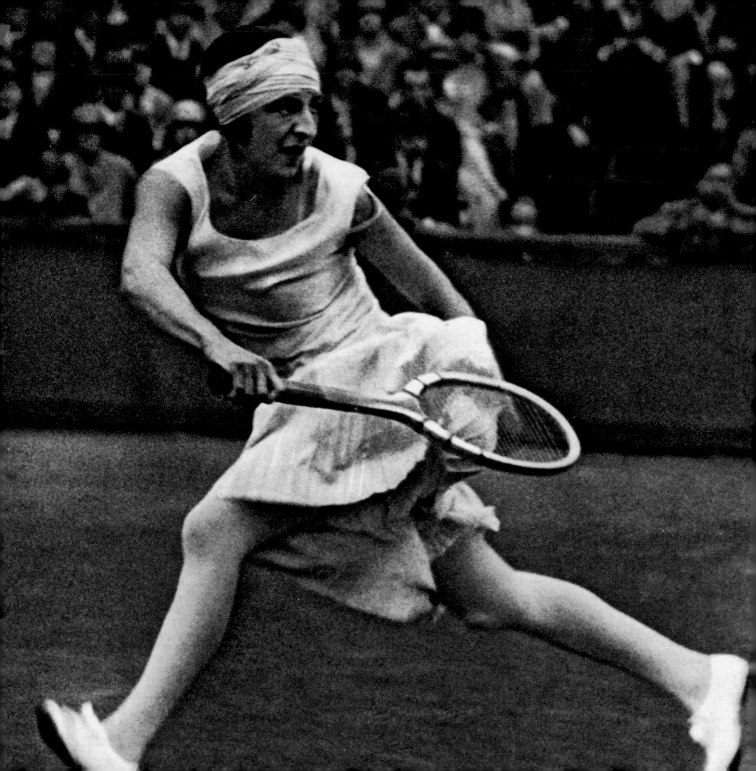

SUZANNE LENGLEN
1899–1938

She felt about a love set as a painter does about his masterpiece;
each ace serve was a form of brushwork to her, and her fantastically
accurate shot-placing was certainly a study in composition.
—Janet Flanner on Suzanne Lenglen

The audience in the stands and in the Royal Box rubbed their eyes when Suzanne Lenglen entered center court at Wimbledon to defend her title on July 1, 1921: the twenty-two-year-old French woman dared to appear on the "sacred lawn" wearing a knee-length silk dress without a slip and white socks, with her upper arms exposed and plenty of makeup applied. In view of this affront to the strict Victorian dress code, her overpowering 6:2 and 6:0 victory over her opponent, the American Elizabeth Ryan, was of minor importance.

Suzanne Lenglen brought glamour to the world of the "White Sport." Her tennis dress was a creation by the couturier Jean Patou, and she was distinguished by other surprising accessories as well: "She wore a white fur cape over her white tennis costume," reported the American Bill Tilden, winner of the men's tournament at Wimbledon,

Suzanne Lenglen in her scandalous
tennis dress, ca. 1924.

"and around her head a crimson band so flaming that I earnestly hoped no bull was in the neighborhood." Suzanne Lenglen's dynamic style of playing was at least as spectacular as her outfit: "Her volley is . . . an arrow from the bow," the reporter A. E. Crawley wrote enthusiastically. "And an arrow from the bow is Suzanne herself. . . . She was 'The Diana of Tennis.'" The euphoria of the British journalist was quite appropriate. Between 1919 and 1925, the "goddess," as the contemporary press called her, won fifteen titles at Wimbledon alone, including six singles titles, and two gold medals at the Olympics. She became one of the first female international sports stars.

Lenglen's considerable career was originally born of necessity. From childhood, the daughter of a well-off family in Compiègne in northern France suffered from severe asthma. Her father, the businessman Charles Lenglen, hoped to improve her health by teaching her tennis—a sport that he himself had tolerably mastered. To his great pleasure, Suzanne turned out to be very talented and soon became a member of a storied tennis club in Nice, where the Lenglens owned a vacation home. The ambitious Charles Lenglen organized his daughter's training and managed her. In 1914, had she already reached the final of the French championships, and in 1919, after an involuntary interruption of her career owing to the First World War, she won Wimbledon.

Lenglen was not only talented but also a perfectionist. Her will to win was legendary and inspired

Tennis fashions by Patou, from
Art, goût, beauté, ca. 1925.

not only sports journalists but also the writers of the time: "He probably loved to win as much as Lenglen, for instance" Hemingway wrote of an ambitious protagonist in his novel *The Sun Also Rises*. Indeed, anything but leaving the court as victor was out of the question for the "goddess." Asked about her tactics by reporters, she responded: "I don't think I have any. I . . . think of nothing but the game. I try to hit the ball with all my force and send it where my opponent is not." When necessary, she employed unconventional means: between sets she drank sugared cognac as a stimulus and sometimes cursed loudly when she missed a stroke. Apparently, this was conducive to success, as Suzanne Lenglen won all the singles matches she played from 1919 to 1925, with the exception of one match at the U.S. Open at Forest Hills in the summer of 1921. During that match against local star Molla Mallory, Lenglen suffered a powerful asthma attack. "Mlle. Lenglen was not herself in the match," commented the *New York Times*, making allowances for the Frenchwoman's illness. Other newspapers were not as gracious, coining the slogan "cough and quit," because after losing the first set she conceded the match, coughing, which to many Americans at the time seemed a flimsy excuse. Lenglen responded to this defeat in her own way: dancing and drinking Champagne at a nightclub in New York. But she got her revenge a year later in the Wimbledon finals: in full possession of her strength, the "goddess" defeated Mallory in two sets, losing only two games.

Suzanne Lenglen's sensational performances increasingly occurred off the tennis court as well. At the gala dinners of high society in Paris and Nice, she often appeared next to fashion designers or accompanied by the numerous young tennis players who swarmed around her. *Vogue* and *Vanity Fair* published entire series of photographs of her in the latest creations by Jean Patou, whose favorite model she was in the mid-1920s. Her trademark, the "bandeau Lenglen," became the most successful article of fashion houses worldwide. Umpteen thousand women wore colorful tulle headbands

over their bob hairdos. "She was the first female athlete to be acknowledged as a celebrity outside her particular sport," the historian Larry Engelmann wrote, adding that at the time "a visit by celebrities to the Riviera without an audience with Suzanne was like a visit to Rome without an audience with the Pope." The actors Mary Pickford, Douglas Fairbanks, and Rudolph Valentino, as well as King Gustav V of Sweden, were just a few of those whom the "goddess" received in her villa on the Côte d'Azur.

My method? I don't think I have any.
I . . . think of nothing but the game.
I try to hit the ball with all my force and
send it where my opponent is not.

—Suzanne Lenglen

Suzanne Lenglen played one of the final matches of her career in Cannes in February 1926. Her opponent was the twenty-year-old newcomer Helen Wills of California, who would later succeed her as the world's greatest female tennis player. Public interest in the match was enormous. The stands were filled to capacity and spilled over onto the roofs of surrounding buildings, some of which threatened to collapse under the weight of spectators. Lenglen managed to fight off the attack of her younger opponent with only with difficulty, winning in two close sets. In that contest, Lenglen realized she had reached the zenith of her career: "I have done my bit to build up the tennis of France and the world. It's about time tennis did something for me," she told a journalist from the Associated Press. In the United States, she played a series of well-paid exhibition

matches, including one in New York before no fewer than thirteen thousand spectators. After ending her active career, Lenglen wrote instructional books and, in the early 1930s, founded a tennis school in Paris, which she directed until she became fatally ill with leukemia in 1938. Her students later recalled Suzanne Lenglen's style of play just as Janet Flanner described it in her book *Paris Was Yesterday*—as high art. She "felt about a love set as a painter does about his masterpiece; each ace serve was a form of brushwork to her, and her fantastically accurate shot-placing was certainly a study in composition."

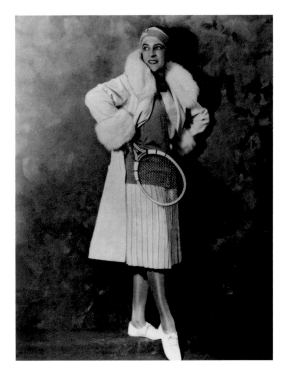

Suzanne Lenglen as a Patou model, 1925.

CLÄRENORE STINNES
1901–1990

*My name is Stinnes, and I am driving around
the world in a car. More questions?*
—Clärenore Stinnes

Seventeen victories within two years—Clärenore Stinnes's results on the racetrack are impressive. The daughter of the influential industrial magnate Hugo Stinnes began driving competitively when she was twenty-four, and her success made her the most popular German racer of her day. Yet the greater the number of her triumphs, the more quickly they lost their appeal, for this adventurous young woman was not at all interested in routine. Clärenore Stinnes's pioneering spirit demanded what she herself called "practical utilization" of her virtuosity behind the wheel and ultimately led to a project that the press celebrated as a "milestone in the history of the automobile." "I decided to drive around the world in a car," wrote Stinnes, "an entirely ordinary jalopy with four wheels and a motor that anyone could buy at the dealer." Clearly she was motivated not only by the sporting challenge but above all by the so-

Clärenore Stinnes after crossing
the Peruvian Andes, 1928.

cial aspect, by the "practical value for the general public": "The trip should show what a modern vehicle is capable of. The car I chose would be subjected to a test that no car has passed to this extent previously, but at the same time would have a pioneering function, instructive for those living in regions in which a car was still an unfamiliar concept."

At a time in which most countries of the world lacked both gas stations and navigable streets, Clärenore Stinnes's project must have seemed like a hopeless enterprise.

The cover of a 1928 issue of *Die Dame*. In the 1920s, it was assumed that women from a certain stratum of society would drive a car.

The enthusiasm with which she approached it and the confidence she radiated had, however, a disarming effect on her contemporaries. "She wears pants, is small and cute, looks like a student, smokes cigarettes constantly, and likes to laugh and does so frequently," as a journalist described the self-confident *garçonne* with a fashionable pageboy haircut and cravat. Even as a child in Mülheim an der Ruhr, Clärenore Stinnes had rejected traditional role models, protested against the intentions of the teachers at her lyceum to turn female students into "obedient, uncritical, young, educated girls," and rebelled against the injustices of the school's director—successfully, thanks to the influence of Hugo Stinnes.

The girl felt much more at home at the side of her father's chauffeur than in school. She helped him with smaller repairs of the family's

vehicles and was indebted to him for her first insights into the function and technology of automobile motors. At eighteen, Clärenore Stinnes passed her driving test and two years later was one of the first women to participate in the recently launched training and racing operations on the AVUS racetrack in Berlin. Her father was an investor in the track, which opened festively in 1921 after a long period of construction and was located close to the Stinnes's villa on Douglasstrasse in Grunewald, where the family had been living since 1920. Hugo Stinnes was not very enthusiastic about his daughter's hobby at first, and he sent her to Argentina for half a year to explore investment opportunities on behalf of his company. Although he was impressed by her final report of the trip, he did not entrust her with a leadership position in the Stinnes empire. Disappointed, she turned her attention to a career in the burgeoning film industry in Berlin. Under the pseudonym Fräulein Lehmann, Clärenore Stinnes began working as an assistant on a production of West-Film GmbH, which her father had founded in 1923 with the Russian producer Wladimir Wengeroff. After being attacked by a monkey during shooting and treated at the Charité hospital, her identity was exposed by the newspapers: "Fräulein Stinnes Bitten by Monkey." The headlines caused her to abandon her ambitions in film—she was no longer interested in a career in which her prominent origins alone would have paved the roads.

At that time, Clärenore Stinnes spent nights drinking and dancing at the Kempinski on Kurfürstendamm or in a racing car on the AVUS. Despite the chronic sinusitis she got from the cold airstream while driving, she decided to make her passion her profession. She found a prominent advocate in the Italian automaker Ettore Bugatti, who was highly impressed when he saw her drive at the AVUS. But only after her father's sudden death—a loss that was nevertheless very difficult for her—did she have the opportunity to realize her project. Hugo Stinnes died in 1924 from a medical blunder following a routine operation. He left behind an empire of well over a thousand interconnected

companies and investments—including coal mines, refineries, shipping companies, banks, and publishing houses—which would experience difficult times under the aegis of his sons, who did not want their sister involved in the corporation. Clärenore had no future in the Stinnes empire, and so in 1924, against the express wishes of her family, she competed in her first official race: the director of Dinos-Automobilwerke encouraged her to enter a competition in Essen. Out of respect for her father's recent death, she once again appeared incognito as Fräulein Lehmann and took third place right off the bat, in a car that achieved a maximum speed of 130 kilometers per hour. "So it happened," she wrote later, "that on the day that would prove decisive for my entire life, I appeared under a different name."

Clärenore Stinnes soon abandoned her pseudonym, however. She started participating in auto races nearly weekly, and from 1925 to 1927 recorded numerous victories. Her greatest triumph was at the international All-Russian Test Drive—a rally from Saint Petersburg (then Leningrad) by way of Moscow to Tbilisi and then back to Moscow. All of the nations with an automobile industry were represented there. Stinnes was the only woman among fifty-three participants and won in her class driving a car by the Berlin automobile manufacturer AGA. The race in Russia, large sections of which were across the open steppe, was at once the inspiration and dress rehearsal for her future trip around the world. "Testing the automobile in raw reality," she felt after her victory at the Russian rally, "that would be a task."

Clärenore Stinnes dedicated every free minute to that task: "I traced the routes on ordnance survey maps, to the extent that they were available, and thought about how to overcome the difficulties of the mountains and steppes, calculating the number of kilometers with compass and pencil. In my thoughts, I set up gas stations and oil depots . . . and in those hours lived only for the journey." Before tackling the geographic hurdles

On the road from Peru to Bolivia, November 1928:
Stinnes's car, an Adler Standard 6, is stuck in a water hole.

that awaited her on her tour around the world, she first had to overcome bureaucratic and financial ones. She was aided in that enterprise by the brilliant diplomatic and business relationships her father had established over the years. The German foreign minister, Gustav Stresemann, organized a diplomatic passport for her, and the ambassadors of the United Kingdom and France arranged the visas necessary to pass through their colonies. The support of the Russian ambassador, Nikolai Krestinsky, with whom she had established a friendship at various receptions in the capital, was valuable too, especially as Russia had a strong economic interest in the German automobile industry. Clärenore Stinnes raised 100,000 marks of sponsorship funds from industry in record time. The Adler-Werke made a car available to her: the recently developed Adler Standard 6, which could be purchased at any dealer. Two mechanics were to accompany her in a second car, and because the project was to be documented and publicized, a cameraman as well.

I would like to experience the world from my own viewpoint.

—Clärenore Stinnes

The director of the Fox-Film-Gesellschaft in Berlin, Julius Aussenberg, recruited the man who would spend the next two years at Clärenore Stinnes's side: the Swede Carl-Axel Söderström. Söderström had already made a name for himself through his early camerawork in Stockholm with Greta Garbo, who would have liked to take his talents with her to Hollywood. On May 25, 1927, just ten days after Aussenberg made his inquiry to Söderström, Clärenore Stinnes set off with 148 hard-boiled eggs, three

evening dresses, and three pistols in her luggage The expedition began in Frankfurt am Main and traversed a total of twenty-three countries.

By way of Vienna, Istanbul, Baghdad, and Tehran, Stinnes made it to Moscow, where the mechanics driving the accompanying car capitulated to the strains of travel and headed back. Ice crevasses as wide as half a meter opened up in front of her car as she and Söderström crossed a frozen Lake Baikal, the first people ever to do so. They put the pistols to use against marauding bands of robbers in the Gobi Desert, and Stinnes employed one of the evening gowns at a gala dinner in Beijing. They continued by ship via Japan, Hawaii, and San Francisco to Lima. Crossing the Andes, they had to clear the road with dynamite. In America, where Henry Ford welcomed them in Detroit and President Hoover at the White House, they traveled on paved roads again. When they arrived at the AVUS in Berlin on June 24, 1929, after two years on the road, they were received triumphantly by, as the *Deutsche Allgemeine Zeitung* wrote, "a large sporting community and numerous men and women from Berlin's society" amid a "crossfire of photographers." The route of nearly 47,000 kilometers that Clärenore Stinnes navigated was longer than the circumference of the earth—just as she had planned it in advance.

What she had not planned, however—at least not before setting off on her trip around the world—was what happened a year and a half after her arrival in the German capital. In December 1930, Stinnes married Söderström and moved with him to Sweden. There too she was received with open arms as a pioneer and icon of a new unlimited mobility. For many, however, she embodied even more. Her iron will, which could move mountains—with dynamite, if necessary—recalled another important woman: "You," the director Friedrich Wilhelm Murnau said to her, speaking for his contemporaries, "would be the ideal person to cast as the Maid of Orleans."

FURTHER READING

General

Barnet, Andrea. *All-Night Party: The Women of Bohemian Greenwich Village and Harlem, 1913–1930.* New York: Algonquin, 2004.

Beil, Ralf, and Claudia Dillmann, eds. *The Total Artwork in Expressionism: Art, Film, Literature, Theater, Dance, and Architecture, 1905–1925.* Berlin: Hatje Cantz, 2011.

Bouvet, Vincent, and Gérard Durozoi. *Paris 1919–1939: Art, Life and Culture.* New York: Vendome, 2010.

Brown, Susan, ed. *Fashion: The Definitive History of Costume and Style.* New York: DK, 2012.

Coffin, Sarah D., and Stephen Harrison. *The Jazz Age: American Style in the 1920s.* Cleveland Museum of Art, 2017.

Coudert, Thierry. *Cafe Society: Socialites, Patrons, and Artists, 1920–1960.* Paris: Flammarion, 2019.

Glassco, John. *Memoirs of Montparnasse.* Reprint edition. New York: NYRB Classics, 2007.

Hooks, Margaret. *Surreal Lovers: Eight Women Integral to the Life of Max Ernst.* Madrid: La Fábrica, 2018.

Hudovernik, Robert. *Jazz Age Beauties: The Lost Collection of Ziegfeld Photographer Alfred Cheney Johnston.* New York: Universe, 2006.

Mackrell, Judith. *Flappers: Six Women of a Dangerous Generation.* New York: Sarah Crichton Books, 2013.

Marck, Bernard. *Women Aviators: From Amelia Earhart to Sally Ride, Making History in Air and Space.* Paris: Flammarion, 2013.

Meade, Marion. *Bobbed Hair and Bathtub Gin: Writers Running Wild in the Twenties.* New York: Nan A. Talese, 2004.

Metzger, Rainer, and Christian Brandstätter, eds. *Berlin: The Twenties.* New York: Abrams, 2007.

Prinzler, Hans Helmut. *Sirens and Sinners: A Visual History of Weimar Film, 1918–1933.* London: Thames & Hudson, 2013.

Prose, Francine. *The Lives of the Muses: Nine Women and the Artists They Inspired.* New York: HarperCollins, 2002.

Riley, Charles A. *Free as Gods: How the Jazz Age Reinvented Modernism.* Hanover, NH: ForeEdge, 2017.

Rosenblum, Naomi. *A History of Women Photographers.* 3rd ed. New York: Abbeville, 2010.

Simon, Linda. *Lost Girls: The Invention of the Flapper.* London: Reaktion, 2019.

Toepfer, Karl. *Empire of Ecstasy: Nudity and Movement in German Body Culture, 1910–35.* Berkeley: University of California Press, 1997.

Weiss, Andrea. *Paris Was a Woman: Portraits from the Left Bank.* Revised edition. Berkeley: Counterpoint, 2013.

Zeitz, Joshua. *Flapper: A Madcap Story of Sex, Style, Celebrity, and the Women Who Made America Modern.* New York: Broadway Books, 2006.

Josephine Baker

Baker, Josephine, and Jo Bouillon. *Josephine*. New York: Harper & Row, 1977.

Rose, Phyllis. *Jazz Cleopatra: Josephine Baker in Her Time*. New York: Doubleday, 1989.

Anita Berber

Gordon, Mel. *The Seven Addictions and Five Professions of Anita Berber: Weimar Berlin's Priestess of Depravity*. Los Angeles: Feral House, 2006.

Clara Bow

Morella, Joe, and Edward Z. Epstein. *The "It" Girl: The Incredible Story of Clara Bow*. New York: Delacorte, 1976.

Stenn, David. *Clara Bow: Runnin' Wild*. New York: Doubleday, 1988.

Louise Brooks

Brooks, Louise. *Lulu in Hollywood*. Expanded edition. Minneapolis: University of Minnesota Press, 2000.

Cowie, Peter. *Louise Brooks: Lulu Forever*. New York: Rizzoli, 2006.

Paris, Barry. *Louise Brooks: A Biography*. Minneapolis: University of Minnesota Press, 2000.

Claude Cahun

Cahun, Claude. *Disavowals, or, Cancelled Confessions*. Cambridge, MA: MIT Press, 2008.

Downie, Louise, ed. *Don't Kiss Me: The Art of Claude Cahun and Marcel Moore*. New York: Aperture, 2006.

Shaw, Jennifer Laurie. *Exist Otherwise: The Life and Works of Claude Cahun*. London: Reaktion, 2017.

Luisa Casati

Ryersson, Scot D. *Infinite Variety: The Life and Legend of the Marchesa Casati*. Revised edition. Minneapolis: University of Minnesota Press, 2017.

———. *The Marchesa Casati: Portraits of a Muse*. New York: Harry N. Abrams, 2009.

Nancy Cunard

Chisholm, Anne. *Nancy Cunard: A Biography*. New York: Knopf, 1979.

Gordon, Lois. *Nancy Cunard: Heiress, Muse, Political Idealist*. New York: Columbia University Press, 2007.

Amelia Earhart

Butler, Susan. *East to the Dawn: The Life of Amelia Earhart*. Cambridge, MA: Da Capo, 1997.

Earhart, Amelia. *The Fun of It*. Reprint edition. Chicago: Chicago Review Press, 2006.

———. *20 Hours, 40 Min: Our Flight in the Friendship*. National Geographic Adventure Classics. Washington, DC: National Geographic, 2003.

Zelda Fitzgerald

Bryer, Jackson R., and Cathy W. Barks, eds. *Dear Scott, Dearest Zelda: The Love Letters of F. Scott and Zelda Fitzgerald*. New York: Bloomsbury, 2003.

Fitzgerald, Zelda. *The Collected Writings*. Edited by Matthew J. Bruccoli. Boston: Little, Brown, 1992.

Milford, Nancy. *Zelda*. New York: Harper & Row, 1970.

Tamara de Lempicka
Claridge, Laura. *Tamara de Lempicka: A Life of Deco and Decadence*. New York: Clarkson Potter, 1999.
Lempicka-Foxhall, Kizette de. *Passion by Design: The Art and Times of Tamara de Lempicka*. As told to Charles Phillips. New York: Abbeville, 1987.

Suzanne Lenglen
Engelmann, Larry. *The Goddess and the American Girl: The Story of Suzanne Lenglen and Helen Wills*. New York: Oxford University Press, 1988.
Little, Alan. *Suzanne Lenglen: Tennis Idol of the Twenties*. London: Wimbledon Lawn Tennis Museum, 1988.

Lee Miller
Conekin, Becky E. *Lee Miller in Fashion*. London: Thames & Hudson, 2014.
Haworth-Booth, Mark. *The Art of Lee Miller*. New Haven: Yale University Press, 2007.
Penrose, Antony. *The Lives of Lee Miller*. London: Thames & Hudson, 1999.

Kiki de Montparnasse
Kiki de Montparnasse. *Kiki's Memoirs*. Edited by Billy Kluver and Julie Martin. New York: Ecco, 1996.

Kluver, Billy, and Julie Martin. *Kiki's Paris: Artists and Lovers, 1900–1930*. New York: Harry N. Abrams, 1989.

Dorothy Parker
Meade, Marion. *Dorothy Parker: What Fresh Hell Is This?* New York: Villard, 1989.
Parker, Dorothy. *The Portable Dorothy Parker*. Edited by Marion Meade. New York: Penguin Classics, 2006.

Elsa Schiaparelli
Blum, Dilys E. *Shocking! The Art and Fashion of Elsa Schiaparelli*. New Haven: Yale University Press, 2003.
Schiaparelli, Elsa. *Shocking Life: The Autobiography of Elsa Schiaparelli*. London: Victoria & Albert Museum, 2018.
Secrest, Meryle. *Elsa Schiaparelli: A Biography*. New York: Knopf, 2014.

Lavinia Schulz
Meier, Allison. "Avant-Garde 1920s Costumes Reemerge, Revealing Their Makers' Tragic Story." *Hyperallergic*, October 29, 2015. https://hyperallergic.com/248602/avant-garde-1920s-costumes-reemerge-revealing-their-makers-tragic-story/.

Clärenore Stinnes
"Clärenore Stinnes." In *Wikipedia*. Accessed June 19, 2019. https://en.wikipedia.org/wiki/Clärenore_Stinnes.

INDEX OF NAMES